National Gallery of Ireland

Fifty Irish Painters

The National Gallery of Ireland

National Gallery of Ireland

Fifty Irish Painters

by Michael Wynne

The National Gallery of Ireland 1983

First published 1983 by the National Gallery of Ireland, Dublin 2.
Photography by Declan Emerson.
© Michael Wynne and the National Gallery of Ireland 1983.

ISBN 0 903162 07 5

Printed and bound in the Republic of Ireland by Graphic Printers Ltd., Dublin 6.

A BRIEF ACCOUNT OF IRISH PAINTING

There is scarcely no easel painting in Ireland until the second half of the seventeenth century, and the reason for this phenomenon is usually attributed to the political instability of Ireland in preceding centuries. A contributory factor may also be a lack of interest in the visual arts by the soldier-planters granted lands over a wide span of years.

The earliest painters illustrated in this booklet were either trained in the Low Countries or by artists who had studied there. Thus the main characteristics are close to those of the artists working in Great Britain at the same time. The earliest known paintings are mostly portraits, although in the background of some of them there is a landscape most competently handled. Biographical details for almost all the painters are very scant indeed, but certain observations help to locate some of them. For example, it would appear that Garrett Morphey moved in exclusively Jacobite circles, even after the Battle of the Boyne in 1690.

Close comparisons with painting in Great Britain endure, such as the pose of *melancholia* used by Morphey, James Maubert and Charles Jervas. The last named, born in County Offaly, seems to have commuted between Dublin and London, finally settling there and succeeding Kneller as Principal Painter to the King, in 1723. Despite studies in Italy his work has much more in common with Flemish-trained artists than any other School. A little later comes James Latham who is known to have studied in Antwerp, and who in fact was enrolled in the Guild of St. Luke there. His known works suggest that he resided permanently in Ireland after his return from Antwerp. There are some fine portraitists at this period about whom very little is known, such as the elegant Anthony Lee or the slightly less sophisticated Jeremiah Barrett.

Some Irish artists, on maturing, settled in London, never to return; others travelled to and from London, while a few English painters settled in Ireland, never to return to their homeland. Thomas Frye, a most accomplished portraitist, is an example of the first category; even today one can not say that one of his known works was actually executed in his native island. He found favour in London, and to this day a portrait of Frederick Prince of Wales is to be found in the Royal Collections. Stephen Slaughter is an example of an artist who spent considerable periods in both capitals; he is basically an artist of the English School derived from Kneller.

Landscape painting as a profession in its own right was relatively late in emerging in Ireland. While some immigrant and visiting artists have left some interesting canvases, it was not until about 1750 that a fully Irish landscape artist became known. George Barret is about the most important. He executed many splendid works of the spectacular and variegated views in County Wicklow, a short distance to the south of Dublin. He was successful in Ireland and then went across the Irish sea to further success, and some notable commissions. Indeed his income exceeded that of Richard Wilson and his more rugged views were more acceptable to the contemporary critics. Barret was to become a founder member of the Royal Academy, in 1768. Barret had several competent contemporary Irish landscape painters, including George Mullins, James Coy, Richard Carver, and the slightly later Thomas Roberts.

There was a second Irish foundation member of the Royal Academy, the portrait painter, Nathaniel Hone. At an early age he went to London, and executed superb enamel and watercolour miniature portraits. He changed over to painting in oils almost exclusively about the time of the foundation of the Royal Academy. Hone was jealous of the acclaim accorded to Joshua Reynolds. In oils Hone was never really superb, but maintained a very even level of competence which exceeded Sir Joshua's occasional lapses into banality. Hone had two artist sons, Horace and John Camillus, both splendid miniature painters.

The principal training centre for Irish artists was, from the middle of the eighteenth century, the Dublin Society Schools. Here the leading teacher was Robert West, and instruction was in drawing, mainly leading to work in chalks. Numerous Irish artists are first known as portraitists in chalks, of whom the most famous is Hugh Douglas Hamilton. Hamilton apparently is executed numerous small oval pastels (of about ten inches in height) in a day. Hamilton, after a time in London, went off to Rome, where from 1778 he was able to work in a city which had attracted many artists from England and Ireland, as well as many continental countries. There Hamilton was prevailed upon to work in oils, which he did with notable success. Most of his work in Italy, and after his return to Ireland by 1792, consisted of very competent portraits; he had not abandoned his work in chalks, but the exceptional pieces were full-length portraits or portrait groups in oils which are virtually pieces of history painting. He also did a small number of subject such as *Cupid and Psyche in the Nuptial Bower* which is in the National Gallery of Ireland.

James Barry of Cork went off to Italy to study, on the advice and patronage of Edmund Burke. He reached a high level of achievement, leaving at Bologna, where he sojourned on his return journey, a large canvas, *Philoctectes*. He was made a member of the Accademia Clementina there. Back in London Barry commanded considerable respect, and became Professor of Painting at the Royal Academy. Truculent by nature, he quarrelled with the Academy and was expelled. Barry was about the most important history painter in England of his time, and finished as a labour of love the enormous murals in the premises of the Royal Society of Arts, close to the Strand, in London. This series depicted *The Progress of Human Culture*. Several easel paintings, some of them quite large, hang in various galleries to represent a painter of history painting in Great Britain and Ireland, almost unique before the age of Neo-Classicism.

The polished modelling echoing sculpture which is the hallmark of great neoclassical painters such as Jacques-Louis David or Ingres does not appear to have found a true disciple in Ireland. Yes, there are works here and there which could be representative of the style, but there is no dedication to this school. In some ways this is rather strange, because sculptors and architects in Ireland have left a considerable legacy in this idiom.

The developing Romantic movement attracted some Irish artists. The most important is James Arthur O'Connor, whose canvases of scenes in County Wicklow, where there is an abundance of dramatic scenery, epitomize pictorially the principles of the writers of the Romantic movement. His friend Francis Danby, who settled in England at an early age, is one of the principal exponents of the Romantic School in Britain. Irish artists such as Nicholas J. Crowley and Richard Rothwell produced other examples of Irish Romantic painting.

Throughout the core of the nineteenth century there is a group of Irish landscape painters who are competent if not very exciting. The open-air painting of artists like Corot, Daubigny and Harpignies drew Irish interest. A precursor of this style is to be found in *A View of the Rye Water near Leixlip* by William Davis (who became a solid representative of the Victorian style in Liverpool). In this painting, if, as would appear most likely, it was painted before the artist left for England at the age of twenty-three, one has a remarkably fresh depiction of a typical Irish view painted with the qualities of great exponents of the open-air school. Several Irish painters reached the famous Barbizon and Fontainebleau areas of France, many of them after a few years in the Low Countries, especially at Antwerp. Walter Osborne and Nathaniel Hone the Younger absorbed the lessons of the artists's colonies of open-air painting in France, and applied them to views when they returned home. Osborne regrettably died when he was just at the climax of his maturity.

A major development in the history of European painting took place towards the end of the nineteenth century in and around the small French town of Pont Aven. Impressionism was ceding to new ideas, and artists such as Gauguin and Van Gogh were ploughing new furrows. There in the midst of this new surge of creativity and interpretation was the Irishman Roderic O'Conor, who, while still somewhat underestimated internationally, is rarely omitted from any major exhibitions of Gauguin and the Pont Aven School. O'Conor has left many landscapes, but also strong portraits and vivid figure studies. Many of his paintings can be included with the *Fauve* movement. Another, somewhat later, Irish painter whose best works derive from the same location and School is William J. Leech.

The more traditional or academic approach to painting in Ireland continued strongly in both landscape and portraiture. Coming after Sarah Cecilia Harrison, Sarah Purser and John Butler Yeats, are John Lavery and William Orpen, very successful society portraitists of high quality, both of whom had served as official war artists in World War I, and who were knighted for their services. As well as portraits, and of course war "reporting", both artists executed some delightful subject works. By their example and teaching these artists endowed early twentieth century Irish art.

Late Cubism was the heart of the training of both Mainie Jellett and Evie Hone, who were to develop in rather different ways. In Irish art of the first half of the twentieth century Jack B. Yeats occupies a special place. From being a graphic artist in a very realist way he developed a most individual and personal style. One may think of Impressionism and Expressionism. Yeats does not fit into any School. With roots in Irish landscape and myth Yeats is purely himself.

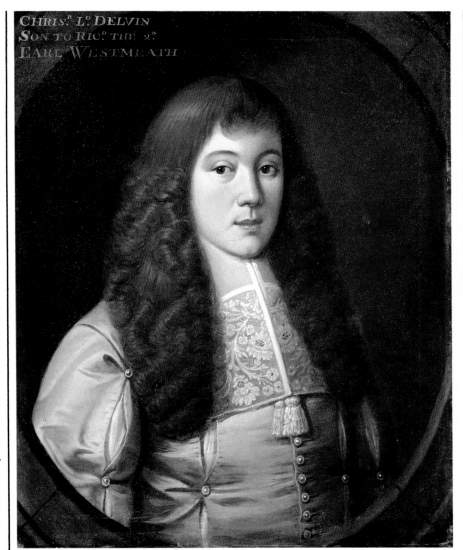

Smitz, an artist trained in the Low Countries, is reputed to have come to England shortly after the Restoration of Charles II in 1660. He was admitted to the Dublin Guild of Saint Luke in 1681, and must have been in Ireland before then. James Maubert (see p. 3) is first recorded as having taken lessons from Smitz in Dublin. Three portraits of members of the Nugent family, Earls of Westmeath (including that reproduced here) are in the Gallery's collection. Of these that of Lord Delvin is the "coolest" in style; his face has an almost egg-shell finish, while his clothes appear to be of silk or satin.

The sitter of this portrait was the son of the 2nd Earl of Westmeath, and father of both the 3rd and 4th Earls. This painting must have been executed about 1665, and one can not rule out the possibility that Lord Delvin sat to Smitz in London. Cross-channel traffic was quite a routine matter, especially for members of the merchant and landed classes, even in the seventeenth century.

This, like many portraits in the Malahide collection, came through intermarriage. The portrait collection at Malahide was not the largest in the country; however, by virtue of the number of early portraits (of the late seventeenth and early eighteenth centuries), and because of the presence of portraits of members of other prominent Irish families, mainly related to the Talbots by marriage, it had a special historical quality. Finally, it was a stronghold of Jacobites.

Christopher, Lord Delvin, d. 1680.
GASPAR SMITZ, *fl.1662-c.1707.*
Oil on canvas, 72 x 60 cm. Purchased at Malahide Castle in 1976.

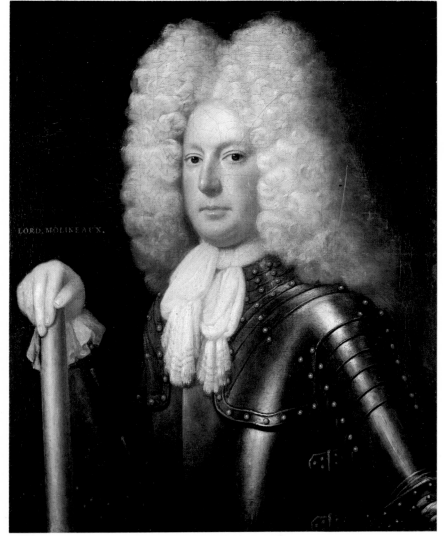

Caryll, 3rd Viscount Molyneux of Maryborough.
GARRET MORPHEY, *fl.*1680-1716.
Oil in canvas, 74.9 x 61 cm. Purchased at Malahide Castle in 1976.

Morphey is a delightfully tantalizing person, which to a large extent is due to the history of the period in which he was working. Nothing is known about his origins. His earliest documented work is lost, but is known through the engraving of it by J. Van der Vaart. Whether it was a drawing or an oil portrait is not known. It represents the recently canonized martyr Oliver Plunkett, Archbishop of Armagh and Primate of All Ireland, whose journey to the scaffold at Tyburn was begun by the perfidious perjury of some witnesses at a court in Dundalk in 1679.

Morphey was well known to be a Roman Catholic, and portraits by him are numerous, mainly to be found in the houses of Jacobite families, many of them within the Pale. The portrait reproduced here came from Malahide Castle, County Dublin. Morphey's style is basically that of the painters of the Low Countries at the time of his training; this does not necessarily mean that he studied on the continent, because he could have acquired his style in either England or Ireland. A portrait such as that reproduced here can scarcely claim to have the merits of a Rigaud, or an early Largillière, but it is very competent. Morphey's treatment of lace, whether on male or female portraits, is a characteristic by which many of his works can be identified.

The 3rd Viscount Molyneux had a chequered career; however, under James II he was Lord Lieutenant of Lancashire and Admiral of the Narrow Seas. Maryborough (Portlaoise today) was so christened after Queen Mary, while Philipstown (Daingean today) in the adjoining County was named after her husband, Philip II, King of Spain, in his own right.

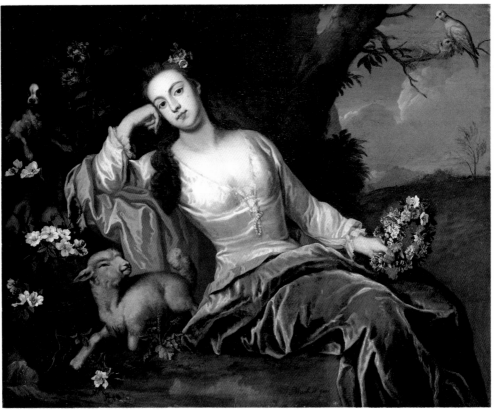

Henrietta, Duchess of Bolton, d. 1729.
JAMES MAUBERT, d. 1746.
Oil on canvas, 120 x 148 cm. Signed: *J. Maubert pinx 1721*.
Purchased in 1980.

James Maubert may have been Irish by birth, because he is noted as a pupil of Gaspar Smitz, a Flemish painter working in Dublin. Many French Huguenot families came to Ireland after the Revocation of the Edict of Nantes in 1685; no proof, however, of Maubert's Irish birth can be provided at present. He seems to have painted mainly in England, though not very many works by him are identified at present.

Henrietta, Duchess of Bolton, is in a pose which was extensively used in English painting from Elizabethan times onwards. It is known as *Melancholia*, and is not unlike the pose of many tomb effigies of the late 17th and early 18th centuries. The Irish painters Garret Morphey and Charles Jervas both used this pose on several occasions. Henrietta has a right to be portrayed in the pose of *Melancholia*, as the picture was painted in the year her husband died. Henrietta Crofts, one of the illegitimate children of James Scott (formerly Crofts), Duke of Monmouth, married, as his third wife, Charles Powlett, 2nd Duke of Bolton, in 1697. The marriage probably took place in Ireland, since Powlett was a Lord Justice of Ireland from 1697 until 1700. Later he returned to Ireland as Lord Lieutenant from 1717 until 1719. The Duke died on the 21st January 1721. The dowager Duchess died in 1729.

4

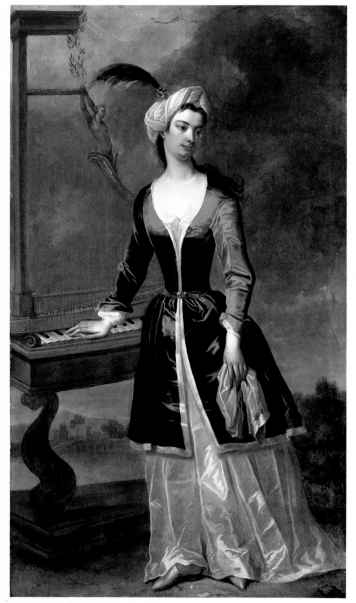

Portrait of a Lady, possibly Lady Mary Wortley Montagu.
CHARLES JERVAS, *c.***1675-1739.**
Oil on canvas, 214.5 x 126 cm.
Presented by Mr. Louis Cohen, in memory of his brother, Israel, 1981.

Jervas was born in the parish of Shinrone, Co. Offaly, about 1675. He went to London as a young man and studied under Kneller. He went to Italy for a few years. On his return he received many commissions, especially from literary circles. On the death of Kneller in 1723, he was appointed principal painter to George I, a position he retained under George II. He paid a couple of visits to his home country. Among the notable people he portrayed were: Addison; "Stella"; Robert Walpole, Earl of Orford; Sir Isaac Newton; Thomas Parnell; Alexander Pope; Dean Swift (many times). In addition to portraits of George II and his Queen, he painted numerous members of the aristocracy.

The sitter in this portrait wears Turkish style dress, which was fashionable for a long period of eighteenth century portraiture, not just in England but in continental Europe as well. The great Swiss master of the pastel, Jean Etienne Liotard, frequently used it, as did, closer to home, Thomas Frye. The musical instrument to the left of the canvas, a clavicytherium, is the vertical ancestor of the harpsichord and spinet. This portrait is one of a pair, presented to the Gallery at the same time. In the second painting the sitter again wears Turkish attire. To reinforce this cult of the Near East the background depicts the great walls of Constantinople (Istanbul), over which appears the profile of the great basilica of Hagia Sophia.

The donor acquired the paintings at the sale of the contents of St. Anne's. Clontarf, Dublin, formerly the home of Archbishop Plunket. Both the painting illustrated here, and its pendant, are well painted, but, quite understandingly, not as refined in execution as smaller portraits, of which that of Dean Swift in the National Portrait Gallery, London, is a superb example.

Latham, from County Tipperary, studied in Antwerp, and was actually enrolled into the Guild of St. Luke there between September 1724 and September 1725. After that there followed a successful career as a portrait painter in Ireland. Documentation about him is scant. A couple of portraits which were engraved provide the firm foundation for the attribution to him of a substantial number of portraits. His style of good solid execution includes "typical high foreheads", "heavy eyes and his confident crisp" depiction of drapery. In the past his work has been questionably attributed to Hogarth. There are many similarities between the two artists, but Latham's distinctive stylistic mannerisms have now been recognised, and give sound reasonable attributions to groups of portraits in Irish country houses. The full-length portrait reproduced here was firmly given to Latham before the Gallery bought another very similarly handled full-length of *Eaton Stannard*, a painting which had been engraved.

Charles Tottenham was Member of Parliament for New Ross, County Wexford, from 1727 until shortly before his death. In 1731 there was a proposal that an Irish surplus of £60,000 be handed over to the British government. Having received news that this matter was to be voted on sooner than expected, Tottenham is reputed to have ridden some sixty miles and strode into the Parliament chamber in his boots, covered in mud, just in time to cast his vote, the vote that retained the surplus for use at home.

The inscription and date on this portrait have been added later. Tottenham does wear stout boots, but neither they nor he are covered with mud.

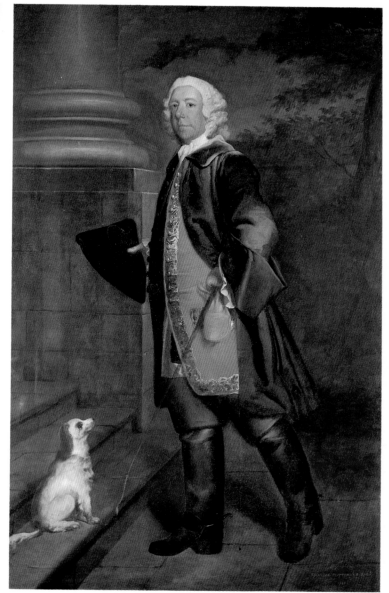

Charles Tottenham, "Tottenham in his Boots", 1685-1758.
JAMES LATHAM, 1696-1747.
Oil on canvas, 221 x 145 cm. Presented by the 1st Earl of Iveagh in 1891.

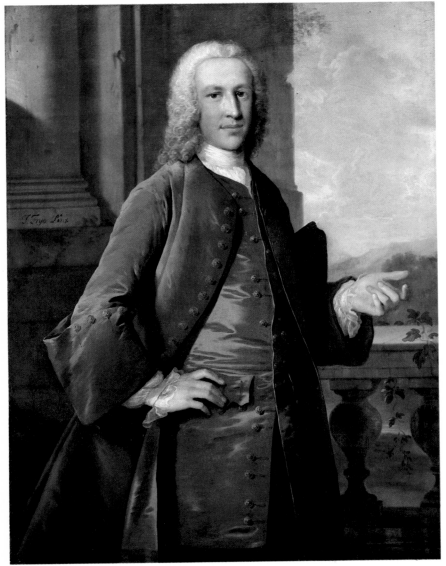

Sir Charles Kemeys-Tynte, 1710-1785.
THOMAS FRYE, 1710-1762.
Oil on canvas, 127 x 102 cm. Signed: *T. Frye pinx. 1739.*
Presented by Mr. G. Hannen, London, 1930.

Nothing is known about the artistic training of Thomas Frye. Indeed among the very few portraits of Irish sitters, out of a total known *oeuvre* of more than eighty works, it is impossible to prove that one of them was done in Ireland. His earliest recorded work is a pair of pastels, which might indicate some Dublin training in that medium, which was to become a hall-mark of many Irish-trained artists for the rest of the century. In 1736 Frye was well established in London, when he was commissioned to paint a portrait of Frederick, Prince of Wales, for the Company of Saddlers. Frye's known work is confined to portraiture, but he ranged over a wide selection of media, from watercolour miniature of the highest quality, to excellent mezzotints, now much sought by collectors.

For years the portrait reproduced here masqueraded as *Sir Thomas Wharton,* a man who never existed. The real identity of the sitter is established by a photograph published in 1908 of the Saloon of Halswell Park, Somerset (the Kemeys-Tynte home). The location is very appropriate since Frye painted other members of Somerset families, including John Allen of Bridgewater, one of whose portraits is in our collection.

Frye was a founder of the Bow porcelain works, and its first manager, from 1744-1759. His influence on its designs remains to be studied in depth. As a portrait painter Frye's quality is now recognised; formerly, unsigned works were considered as dubious Hogarths. Frye seems to have received a continental influence from an early stage, perhaps first through Philip Mercier. Later he copied Rosalbas, and openly stated that in his late mezzotints he was taking direct inspiration from Piazzetta.

Slaughter was born in London, and studied painting under Kneller. Later he travelled on the Continent, and was definitely in Paris in 1732 when he signed a portrait there. By 1734 he had arrived in Dublin, apparently well introduced, starting out by painting Nathaniel Kane, the Lord Mayor, a portrait now in the Gallery's collection. This visit appears to have been short, because many English paintings by him are known throughout the following decade, with a notable absence of Irish sitters. His next visit to Ireland must have been longer, beginning about 1743 and continuing until 1748. He did many portraits of the Inchiquin and Dunraven families (O'Brien and Quin, respectively); several prelates and their wives sat for him; so, too, did members of landed families. The identity of the sitters in the painting illustrated here remains unknown.

All Slaughter's portraits reveal a great interest in fine clothes, for which the well-to-do Irish had a distinct propensity. The highlights of silk and satin dresses are skilfully handled; ribbons, lace and braid delighted him. The backgrounds, as in this portrait, seem to be treated as if they were drawn from stage sets.

The impact of Slaughter's style on fully Irish artists seems to have been exaggerated. By the date of his first known Dublin portrait, 1734, Latham was established, painting portraits with style and elegance, as were Maubert, Lee and Frye.

Slaughter was Surveyor of the King's Pictures from 1744; to judge by the number of paintings known at present from the last fifteen years of his life, his output appears to have slowed down dramatically.

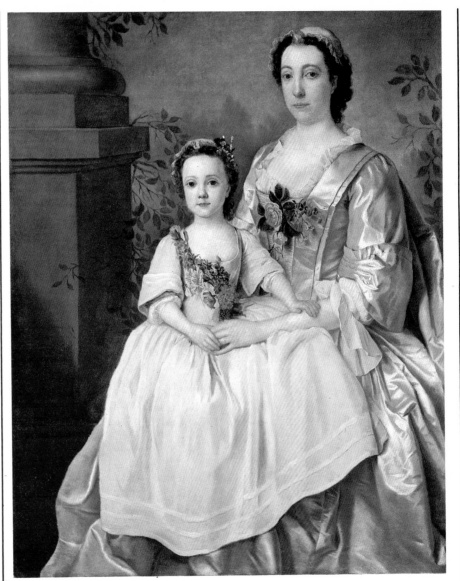

A Lady and Child.
STEPHEN SLAUGHTER, 1697-1765.
Oil on canvas, 130 x 104 cm. Signed: *Stepn. Slaughter pinxt 1745.*
Bequeathed by Sir Hugh Lane, 1918.

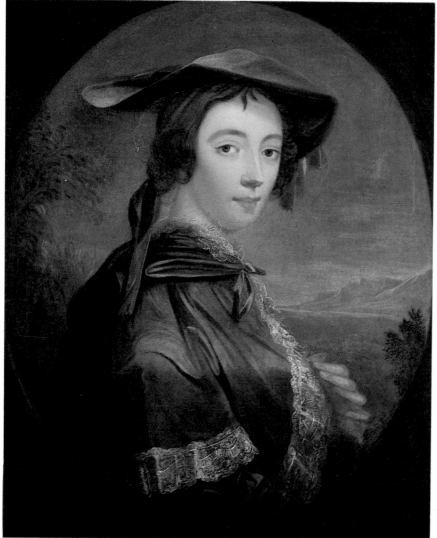

Margaret (Peg) Woffington, 1718-1760
JOHN LEWIS, *fl.*1740-1769.
Oil on canvas, 74 x 62 cm. Signed: *Jn. Lewis April 1753*
Purchased in 1907.

Nothing is known at present about Lewis's origins and training. A very competent portrait signed by him in 1740 is his earliest recorded work. Painting portraits was only one side of his career, since as a scenographer he is very well known. He was the first scene-painter to have been permanently on the staff of a Dublin theatre, the Smock Alley. Shortly before the portrait illustrated here was painted, Thomas Sheridan was the director of Smock Alley and employed Lewis. Sheridan's portrait by Lewis (now in the Gallery) was also painted in 1753.

The Dublin gossips had a great time when Sheridan brought Peg Woffington down to his house in County Cavan, where it was arranged that she should renounce the Church of Rome and be received into the Church of Ireland. The most likely motive for this conversion was to enable her to receive an annuity of £200 a year, bequeathed to her by the London theatre director, Owen MacSwiney. As an actress Peg Woffington was renowned in London, and an outstanding success in Dublin.

Lewis's portrait of the actress is extremely competent; it is elegant in rather a coy way; the profile with the face turned three-quarter towards the viewer is delightfully set against a background of landscape (probably stage scenery). The dress is handled in a series of converging planes. This style reveals the portraitist's profession of sceno-grapher, although without prior knowledge of this aspect of the artist's career one would not have guessed it. Not many works by Lewis are known to exist at present, and understandably no stage sets have survived.

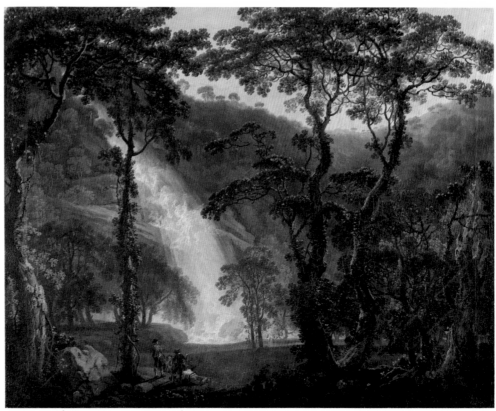

A View of Powerscourt Waterfall.
GEORGE BARRET, 1728/32-1784.
Oil on canvas, 100 x 127 cm. Purchased in 1880.

Barret was a Dubliner born and bred. He learned to draw under Robert West, an artist and teacher who did more than any other individual to lay the foundations of the success of Irish painting in the second half of the eighteenth century. It was Edmund Burke who encouraged Barret to go out and paint landscapes from nature itself. Lord Powerscourt's demesne at Enniskerry, County Wicklow, a mere twelve or thirteen miles from Dublin, abounded in a variety of landscape both placid and dramatic.

This substantial canvas, portraying one of Ireland's most renowned waterfalls, undoubtedly belongs to Barret's early maturity. The painter has positively responded to Burke's direction to observe nature; the verdant cliffs flanking the torrent of water, the strongly drawn trees in full leaf, and the richness of the paint itself depict a scene that has scarcely changed since Barret finished this work well over two hundred years ago.

Barret removed to London in 1762. Success awaited him. Soon he was reputed to have been earning about two thousand pounds a year, while Richard Wilson, his greatest English contemporary in this realm of painting, was barely able to sustain himself by his art. Barret was invited to become a founder member of the Royal Academy, and was faithful in exhibiting at its annual exhibitions. He painted series of paintings for various patrons, but taken as a whole these do not match in quality individual canvases based on studies of particular localities. Barret spent his income as he earned it; after his death the Royal Academy generously provided a modest pension to his widow.

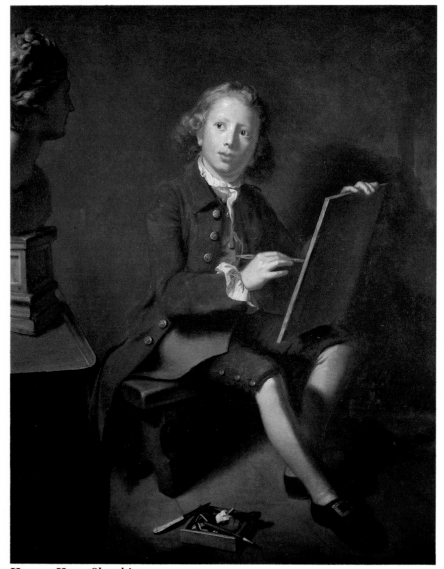

Horace Hone Sketching.
NATHANIEL HONE THE ELDER, 1718-1784.
Oil on canvas, 128 x 105 cm. Purchased in 1954.

Hone was born into a prosperous Dublin merchant family. Nothing is known of his artistic training. He first comes to notice as an artist through his absolutely splendid enamel portrait miniatures. These are of the finest quality and place Hone as a worthy successor to Zincke in this medium.

At the foundation of the Royal Academy Hone was honoured by being made one of the original members. It would appear that it was about this time that he took to painting in oils more deliberately. This may in part be due to the pontificating of Joshua Reynolds, and a general opinion that miniatures were slight. This totally misrepresented the challenge of the miniature technique as practiced at the level of Hone's achievement, and also the fact that the enamels had to pass through "the fiery ordeal" of the furnace.

Hone's portraits in oils are very fine and robust; he received many commissions. In addition he did at least seven *Self-portraits*. His children he also painted on a number of occasions, including the portrait of the young Horace reproduced here. Formal yet informal, this is one of Hone's finest paintings, where the studio apparatus appears to have been nonchalantly strewn around.

In the eighteenth century, children with an aptitude for art, and encouraged by their parents, would have commenced to sketch and study from about the age of ten. Horace Hone was to become a very distinguished and successful miniaturist. As well as painting in watercolours on ivory, Horace also used the enamel technique, occasionally on a relatively sizeable scale, as, for example, in his portrait of the *Duke of Rutland, Lord Lieutenant of Ireland*, in the National Gallery of Ireland.

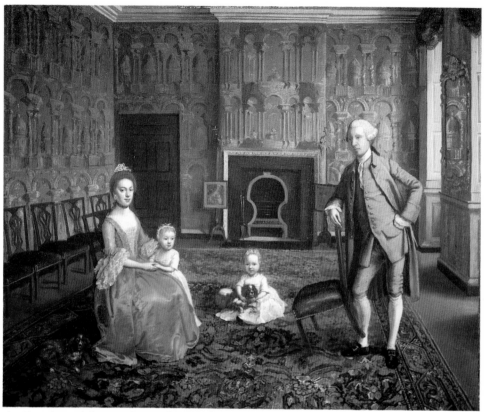

An Interior with Members of a Family.
PHILIP HUSSEY, 1713-1783.
Oil on canvas, 62 x 76 cm. Purchased in 1973.

Hussey came from Cloyne, County Cork. He went to sea and survived several ship-wrecks. His interest in art developed at sea when he whiled away some hours by drawing the figureheads of ships. Thanks to the patronage of Lord Chancellor Bowes, Hussey was able to become a professional painter. Apparently he was successful but relatively few documented works by him are known. A group of patrons are to be found in the south-west; the O'Briens of Dromoland, the FitzGeralds of Glin, and the Leslies of Tarbert.

The attribution of the painting reproduced here is purely on stylistic grounds. Depicted is a charming family group, whose names remain anonymous. The painting is tantalizing from other points of view. The name of the house is not known; while it would not have been enormous, the size of the room is sufficient to indicate that it would have been notable; the wallpaper is highly distinctive, yet specialists in the study of this have been unable to say where it was made; the fire-grate is quite singular, yet no one, so far, has found one similar.

The family is shown in a reception room. In larger eighteenth century Irish houses there was no dining room as we know it today. When a meal was to be served a table or tables were brought to the centre of a room and chairs were drawn in for the assembled company. After the meal the chairs were put back in place along the walls, as in this picture.

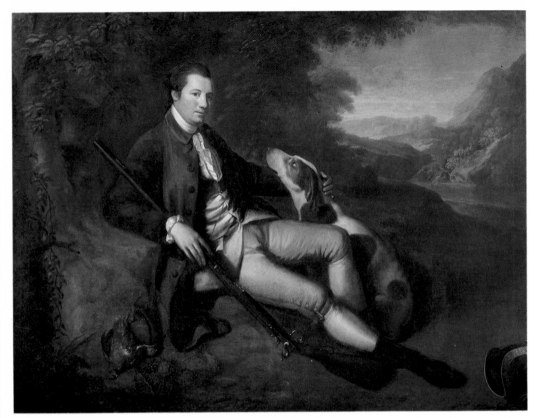

A Gentleman with a Gun and Dog.
ROBERT HUNTER, *fl.*1745-1803.
Oil on canvas, 152 x 198 cm. Signed: *R. Hunter pinxit 1775.*
Purchased in 1971.

At present virtually nothing is known about Hunter's family apart from the fact that he came from Ulster. About the middle of the eighteenth century he was firmly established in Dublin as a portrait painter; in fact he was probably the most fashionable artist of portraits until his practice diminished with the arrival from London of Robert Home.

Hunter, by all accounts, was a very agreeable person, and dedicated to the welfare of the arts and sciences. Among his friends were Thomas Prior and "Premium" Madden, two major figures in the development of the Dublin Society. Inevitably, the majority of Hunter's sitters were people in public life, from Lords Lieutenant to judges, members of parliament and clergymen.

Almost certainly the painting reproduced here is that which was sold by auction at Bellevue, County Wicklow, in 1906. That property belonged to the La Touche family, notable bankers in Dublin in the eighteenth century. Bellevue is in the northern part of County Wicklow, at Glen O The Downs. The sitter must surely be a La Touche, and given the dimensions of the painting it was most probably commissioned. Peter La Touche owned Bellevue in 1775; the landscape setting is very evocative of County Wicklow and may even be an attempt to depict the well wooded hills at Bellevue. One cannot rule out the possibility that the inspiration for the landscape came from Luggala, another La Touche property in a wilder part of County Wicklow.

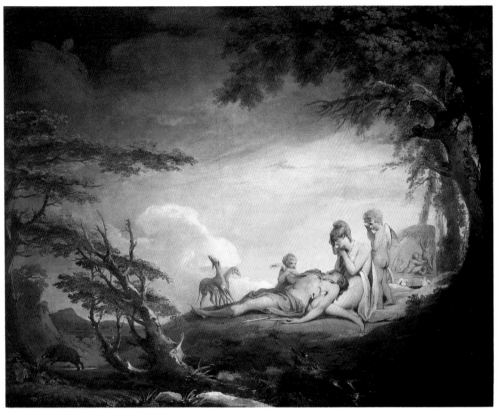

The Death of Adonis.
JAMES BARRY, 1741-1806.
Oil on canvas, 100 x 126 cm. Signed: *Jas. Barry.*
Presented by Mr. and Mrs. R. Field, in 1959.

Barry was born in Cork, but came to Dublin in 1763 to further his studies. Edmund Burke befriended him, and Barry was deeply interested in Burke's theories of the sublime and the beautiful. It was Burke who also financed Barry's sojourn in Italy from 1766 to 1771.

When Adonis grew up to become a handsome young man Venus fell in love with him. An intrepid hunter, Adonis's dogs aroused a wild boar, and, against all his efforts, Adonis was mortally wounded by the ferocious animal. At a distance this painting may not appear very striking. Closer inspection reveals a most delicately painted group of figures, with Venus mourning her beloved. Adonis's hounds plaintively cry out against the horizon. The entire central group is enclosed by a most carefully composed landscape. Barry's brushstrokes flow eloquently throughout this picture.

Barry was the first Irishman to have been made a member of the Accademia Clementina, in Bologna. In London he became a member of the Royal Academy, and later its Professor of Painting. Cantankerous and troublesome, Barry was finally expelled from the Academy. He persevered and finished the great series of wall paintings illustrating *Human Culture* in the principal room of the Society of Arts building at the Adelphi, off the Strand, in London. This was a labour of love since he received no pay. The six huge canvases showed that history painting was still possible by artists in these islands, even though Barry's achievement produced no followers, or patrons who were prepared to pay artists for such work.

A Landscape with a River and Horses.
THOMAS ROBERTS, 1748-1778.
Oil on canvas, 42.5 x 52.5 cm. Purchased in 1877.

Thomas Roberts was a son of the distinguished Waterford architect, John Roberts, who designed both cathedrals in that city. The young Roberts trained at the Dublin Society's Schools, and later was apprenticed to George Mullins, a successful landscape painter who also kept an ale house. The young Roberts concentrated on landscapes; he seems to have had a particular interest in the ideal or classical landscape which depicts nowhere in particular, but, in a carefully composed view, orchestrates nature in a serene fashion.

It invariably includes a perspective towards a horizon which is reached after several planes of modulated light and shade. Such an ordered panorama is to be found in the left hand side of the work illustrated here. The right hand portion may well depict an actual location. Unlike many excellent landscape painters, Roberts could cope more than competently with both human figures and animals. Roberts is a most painstaking painter, delicately treating the leaves of the trees or the tinkling of a stream around protruding stones.

Roberts also painted many actual scenes. A particularly fine example portrays the town of Ballyshannon perched above the Falls which terminate Lower Lough Erne. His greatest achievement known at present is the set of four large canvases showing different sections of the landscaped park at Carton, seat of the FitzGeralds, Earls of Kildare and Dukes of Leinster.

Roberts, a consumptive, died at Lisbon at the age of thirty; he had gone there for the benefit of his health. Exhibition catalogues record a much wider range of subject matter than that currently known in secure examples of the artist's work.

An Actor between the Muses of Tragedy and Comedy.
THOMAS HICKEY, 1741-1824.
Oil on canvas, 102 x 108 cm. Signed: *T. Hickey 1781*.
Purchased in 1925.

This graceful and delicately painted composition undoubtedly owes a debt to Reynolds's *Garrick between the Muses of Tragedy and Comedy*, a work of 1762. Hickey has painted in the first line of a couplet by Milton:

"Hence, the vain deluding joys,
The brood of Folly without father bred." *(Il Pensoroso)*

The artist was born in Dublin and trained at the Dublin Society's Schools. He emerged, like so many of the artists of that academy, as a very competent por-

traitist in chalks. He spent several years in Italy in the 1760s. On returning, he spent a mere three years in Dublin before establishing himself in London. In 1778 he was in Bath, and in 1780 he embarked for India. The ship on which he was travelling was captured by the French and Spanish fleets. Hickey was put ashore at Cadiz and given permission to return to England. He went to Lisbon with a view to sailing from that port. He must have been known to English residents there, or else decided to advertise his profession, since he

dallied in Lisbon and painted the portraits of several prosperous Portuguese in addition to the English emigrés.

He set sail again for India, arrived in Bengal in 1784, and took a fine house in Calcutta; he visited other centres in India and returned to England in 1791. Clearly an intrepid traveller, he went as official portraitist with Lord McCartney's expedition to Peking in 1792 to 1794. In 1798 he went to India again and remained there for the rest of his life.

A View of the Lower Lake, Killarney.
JONATHAN FISHER, *fl.*1763-1809.
Oil on canvas, 39.8 x 52 cm. Purchased in 1966.

Unusual for an Irish artist at that time, Fisher was already a successful woollen draper in the Liberties of Dublin (that area near St. Patrick's Cathedral), before he embarked on a career as an artist. Nothing precise is known about his training. He began to exhibit paintings in the 1760s. From 1778 his post as Supervisor of Stamps in the Stamp Office was no doubt a sinecure which would have guaranteed a basic living for his wife and family.

In 1770 he had six large views of Killarney engraved from his paintings and published in Dublin. In 1772 six large views of Carlingford Lough (which divides Counties Louth and Down) were engraved from his paintings and published in London. Published in Dublin in 1789 were twenty views of the Killarney area aquatinted by Fisher himself from his own landscapes. These smaller engravings are much more attractive than the earlier ones. The painting reproduced here is almost certainly the basis for one of the aquatints, in which there are only but slight alterations. Unlike many of Fisher's oils, which tend to be a bit solemn and lugubrious, this delightful view shows the lake on a very tranquil day, which no doubt was responsible for the light colours and delicate treatment of rocks and foliage.

Later Fisher embarked on a greater project in aquatints, which, when completed as a volume in 1792, comprised sixty views. Fisher's oil paintings are not numerous as known today. It is very likely, that, having embarked on the engraving projects, he delineated his views mainly in either pencil or watercolour.

A Landscape at Tivoli, Cork, with Boats.
NATHANIEL GROGAN, *c.*1740-1807.
Oil on canvas, 93 x 166 cm. Purchased in 1973.

Grogan was born in Cork, the son of a turner and block maker, to whom he was apprenticed. He had an interest in, and an aptitude for, drawing. Receiving absolutely no encouragement from his family in his desire to become an artist, he enlisted in the army. He returned to Cork and made a meagre living by painting and by giving drawing lessons. Mr. Lane employed him to decorate his house, Vernon Mount, and others gave him similar commissions. Even by the time Strickland wrote his *Dictionary of Irish Artists* published in 1913, Grogan was known mainly for his genre pictures, some of which were very indifferent indeed. Now knowledge of his work is more extensive, mainly due to the re-discovery of a number of signed watercolours and drawings.

Grogan gives to his humblest characters dignity and style. His handling of architectural elements is extremely competent, and his treatment of foliage has a rather distinct characteristic.

Undoubtedly the view illustrated here shows the estuary of the river Lee, looking up towards the city of Cork, but experts of Irish architectural history can not agree on what house is represented so strikingly on the north bank. Perhaps the depiction is not very accurate if one allows for the fact that Grogan worked up his canvas in a studio on the basis of sketches taken outdoors. What is certain is that paintings such as this, and others since discovered, place Grogan in the ranks of Ireland's leading landscape artists of the second half of the eighteenth century, among men like Roberts, Fisher and Ashford.

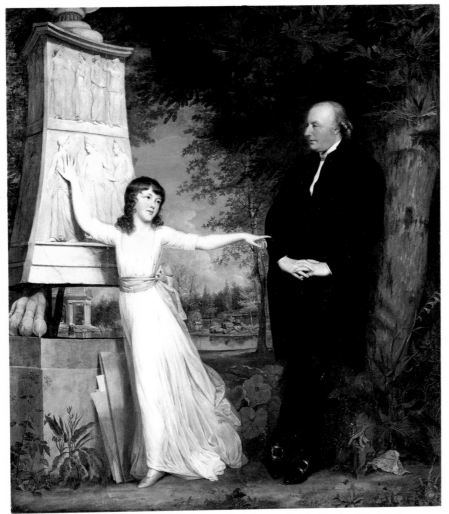

Frederick Augustus Hervey, Bishop of Derry and 4th Earl of Bristol, 1730-1803, with his granddaughter, Lady Caroline Crichton.

HUGH DOUGLAS HAMILTON, c.1739-1808.
Oil on canvas, 230 x 199 cm. Purchased in 1981.

Hamilton was a very successful portrait painter in Ireland, and then England, before he went to Rome in 1778. He was best known for his delightful small oval pastels, but also worked in oils. In Rome Hamilton was also successful, finding patrons among the Grand Tourists, the exiled Stuart family, and fraternising with artists, both native and foreign. The great English neo-classical sculptor, Flaxman urged Hamilton to concentrate on oils.

The Earl Bishop was a regular visitor to Rome. For an Englishman planted into high office in Ireland the Earl Bishop quickly grasped the Irish situation. His pastoral concern for his diocese extended to denominations other than the Established Church. He earnestly sought Catholic Emancipation, and was totally against the Act of Union. A zealous clergyman, the Earl Bishop was an indefatigable builder, a collector of discrimination, and a stalwart traveller. The "chain" of Bristol hotels owe their name to the male sitter in this grand double portrait.

The young girl in this composition may have visited Rome with her mother, Countess Erne, in 1790, just before Hamilton set out for his homeland. The setting of this painting is the park of the Villa Borghese in Rome, with the recently completed Temple of Aesculapius by the lake. In the foreground is the lower portion of what is known as the "large altar of the twelve" (gods), which was in the Villa Borghese collection. It was removed to Paris by Napoleon and remains there to this day, in the Louvre.

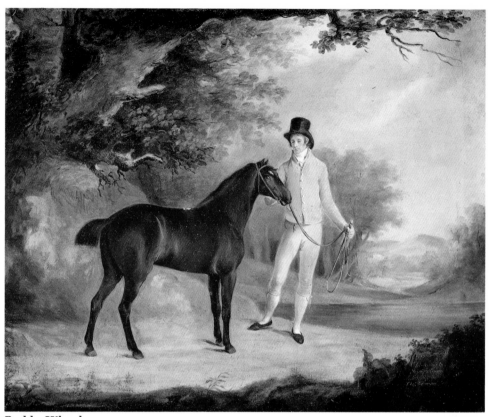

Paddy Whack.
THOMAS ROBINSON, *c.***1770-1810.**
Oil on canvas, 60 x 74 cm.
Signed and inscribed: *Paddy Whack belonged to Major Newberry, painted by Thomas Robinson.* Purchased in 1979.

Robinson was born on the shores of Lake Windermere in the heart of the English Lake District; he trained as a painter under George Romney and soon afterwards came to Ireland. After a few years in Dublin he moved to the countryside near Belfast. Robinson moved back to Dublin in 1808 but died in 1810, apparently after many years of indifferent health.

By adoption an Irish artist, in addition to the history paintings, Robinson enriched the quality of Irish portraiture, and in *Paddy Whack* adds to the modest selection of Irish horse paintings. This is an elegant "portrait group" set in an informal but sophisticated background. Efforts to trace where Major Newberry lived have as yet proved fruitless; however, in all probability the proprietor and his horse lived somewhere in either County Down or County Antrim.

Robinson had a son christened Thomas Romney, but instead of becoming an artist he grew up to be a very distinguished astronomer and mathematician. Thomas Robinson is one of a number of English-born artists who came to Ireland and remained there for the rest of their lives.

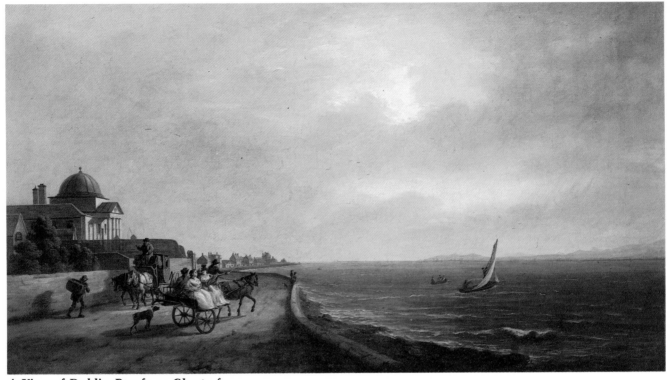

A View of Dublin Bay from Clontarf.
WILLIAM ASHFORD, *c*.1746-1824.
Oil on canvas, 69 x 126 cm. Signed: *W. Ashford 1794*.
Purchased in 1906.

Ashford was born in Birmingham and came to Ireland in 1764. He soon became established as one of the country's finest landscape artists, working in the classical fashion pioneered in the 17th century by painters in Rome like Claude Lorrain. Such was Ashford's standing that, when the Royal Hibernian Academy was incorporated in 1823, he was invited to be its first President. Financially, too, Ashford fared well, living the latter years of his life in the not insubstantial villa in Sandymount, near Dublin,

designed for him by James Gandon.

The building at the left side of this *View* is The Royal Charter School, built in typical Irish Palladian style in 1748. Its express purpose was to educate up to one hundred boys who would, at the appropriate age, be apprenticed to master-mariners. The building was demolished some time in the nineteenth century, an early casualty in the very extensive list of fine buildings removed by subsequent waves of insensitive developers. Ashford's painting is full of mood; the curious hues of grey bear

witness to the moisture-laden air that so often is an integral part of the Irish coastline. The figures in the foreground do not take away the feeling of space and distance; they give the view a genuine sense of reality.

Ashford was a very successful painter. Some of his finest views depict the parkland around the houses of the aristocracy. The Gallery owns two fine views of Dublin, one from Clontarf (well inland from the painting illustrated here), the second from Chapelizod, on the road to the West of Ireland.

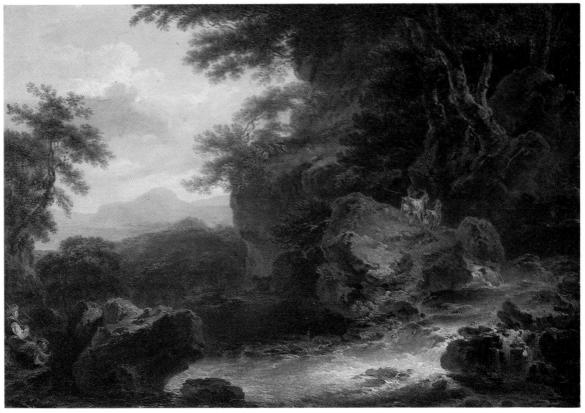

A Landscape.
THOMAS SAUTELL ROBERTS, 1760-1826.
Oil on canvas, 57 x 83 cm. Signed: *T.S.R.*
Purchased in 1923.

Thomas Sautell was the younger brother of Thomas Roberts. Sautell, as he is frequently called, in order to distinguish him from his elder brother, studied to become both an architect and a painter. It would appear that he definitely chose the latter profession, to judge by the number of paintings which he exhibited. There is good reason to believe that Sautell in his early works used a style which is extremely close to that of his elder brother, who died when Sautell was only eighteen. One can not be categorical about that, because of the absence of documented works.

One may hypothesize that works such as that reproduced here represent a middle or mature style. Here, and in similar canvases, the rough, swift, and well-laden brushstrokes strikingly evoke the scenes depicted. Some later paintings, while using a similarly open technique, because of their subject matter, show the artist flirting with the sentimental style of artists like Wheatley, Morland and David Brown.

Sautell's training in architectural studies was put to good use. Some views of Dublin engraved after drawings by him are among the finest records of the city's architectural heritage that have survived to this day. They could only be the work of a professionally trained draughtsman.

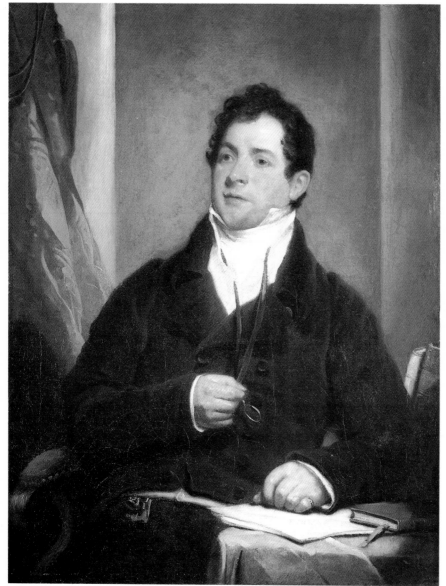

Thomas Moore, 1779-1852.
MARTIN ARCHER SHEE, 1769-1850.
Oil on canvas, 91 x 70 cm.
Presented by Captain R. Langton Douglas, in 1916.

Born in Dublin, Martin Archer Shee received tuition at the Dublin Society's Schools. While still in his late teens he was kept fully employed in Dublin as a portrait painter; it was the visiting Gilbert Stuart who sowed the seeds of a certain discontent in him, and he moved to London. Success was not rapid, and for some time he had to do jobs which would be considered menial for a painter of his stature in Ireland. From his arrival in London in 1788 until 1790 he was seeking a proper outlet for his talent. In the latter year, through Alexander Pope and a cousin, Sir George Shee, he was introduced to Sir Joshua Reynolds by Edmund Burke. Reynolds advised him to enter the Royal Academy Schools, which he did, no doubt swallowing the pride of his early achievement. His patrons covered a very wide spectrum of society. As a gracious and intelligent person he was sought after in literary circles. In 1800 he was elected a full member of the Royal Academy. Thirty years later he was elected President, and subsequently knighted.

Shee's most attractive works are groups of children. Portraits of men of letters, or patrons of the arts, constitute his second most successful type of work. Here again one notes that a certain empathy or sympathy between painter and sitter has a significant role to play.

It is very appropriate that the portrait of Thomas Moore illustrated here should have been painted by Shee, probably towards the end of the second decade of the nineteenth century. Moore was an extremely successful man of letters and music. That this success should have come to him early in life is also due partly, by all accounts, to his gentle, courteous and dignified manner. He was another Irishman sought out by society; the fact that he could entertain his hosts and their other guests in drawing rooms was naturally an added advantage.

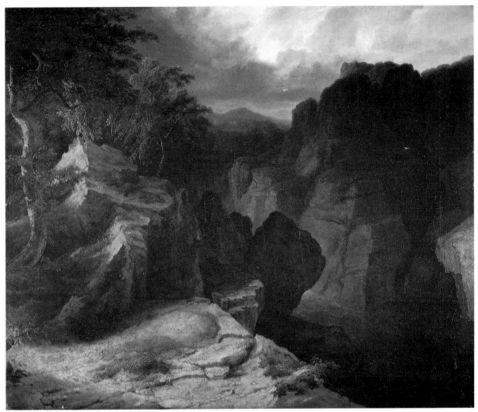

A View of the Devil's Glen.
JAMES ARTHUR O'CONNOR, *c.*1792-1841.
Oil on canvas, 63 x 76 cm.
Presented by Captain R. Langton Douglas, in 1919.

O'Connor was largely self-taught, and spent much time in County Wicklow, where the landscape is varied. With Francis Danby and George Petrie he went to England in 1813, but financial stringency forced him home. Shortly afterwards he went to the West of Ireland, where he was fortunate to find patrons in Lords Clanricarde and Sligo, at Portumna and Westport respectively. In many early works O'Connor is quite realistic and demonstrates a high degree of accurate draughtsmanship.

The artist's regular visits to County Wicklow exposed him to ideal settings for Romantic landscapes. The Devil's Glen is a well-known spot in Wicklow, and the contrast between the sun-bathed rocks and the virtually black ferocious glen makes this painting an honourable example of the Romantic movement which was sweeping Europe at this time. O'Connor did not treat all views of rugged and bleak scenery in the same way as *The Devil's Glen;* towards the end of his career he returned to a more tranquil palette, but such late pictures incorporate some vestiges of his Romantic phase. O'Connor is certainly one of the finest landscape artists of Ireland. He died after an illness which lasted almost two years, leaving his family destitute.

24

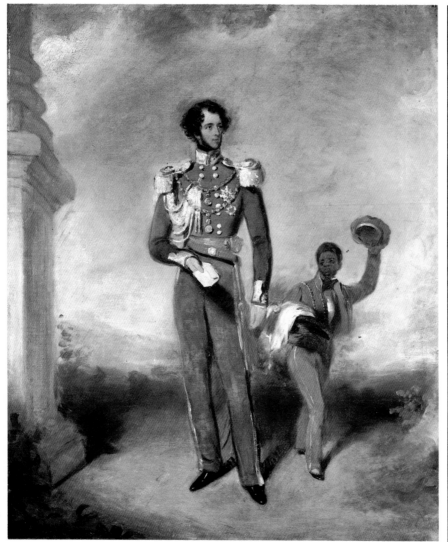

Constantine Henry Phipps, 2nd Earl of Mulgrave, later 1st Marquess of Normanby, 1797-1863.

NICHOLAS J. CROWLEY, 1819-1857.

Oil on canvas, 76 x 61 cm.

Purchased in 1884.

Born in Dublin, Crowley was an infant prodigy. He went to the Dublin Society's School at the age of eight, later moving, in 1832, to the Royal Hibernian Academy's School. In the same year he exhibited at the annual exhibition, and continued to do so almost every year until he died.

Crowley developed a flourishing portraiture practice; he also did a remarkable number of subject pictures, with titles drawn from literature, folklore, and his own imagination. Many of the formal portraits lack interest; so too do some of the more finished subject paintings, because of the fact that they have been overworked. The sketch portrait reproduced here is typical of Crowley at his best, when he is painting freely, rather as if the result was not going to be subjected to scrutiny.

Prior to coming to Ireland as Lord Lieutenant in 1835, Lord Mulgrave had been Governor of Jamaica, and this perhaps explains the presence of the black page. Mulgrave was one of the most popular Lords Lieutenant ever to have come to Dublin. In 1838, a year after this sketch was painted, Mulgrave was advanced in the peerage as Marquess of Normanby. In 1839 he left Ireland, and subsequently served in some of the highest public offices of the British Administration.

Crowley clearly enjoyed painting this sketch with its free brushstrokes creating a liveliness incompatible with a formal portrait. The military uniform of light blue, trimmed with silver lace, epaulettes, and aiguillette, make this a cheerful and very satisfactory painting.

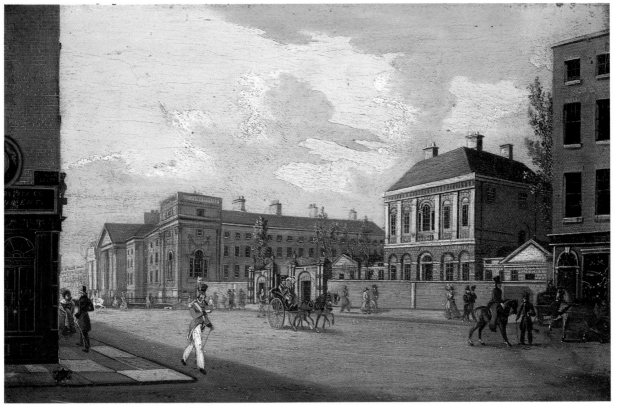

A View of the Provost's House, Trinity College, Dublin.
WILLIAM SADLER, *c.* **1782-1839.**
Oil on panel, 22 x 32 cm.
Purchased in 1921.

As far as is known at present, William Sadler had no formal training, even from his father, also William (who is recorded as a portrait painter) since the latter died about 1788. He is chiefly known for his small views, such as that illustrated here, which invariably were painted on small mahogany panels, with a ration of hessian or other cloth affixed to the rere. The use of these panels has led to the speculation that he may once have worked with a coach-builder or a signwriter. Sadler's views are accurate, somewhat naïve, and provincial. His style is readily discernible, and he applies small dots of paint in a fashion which, artistically, would make him a *very* distant cousin of Canaletto.

The Provost's House seen here is at the end of Grafton Street, and detached, to the south, from the main block of the campus of Trinity College. It is one of the finest town houses in Dublin. Happily it is still used for the purpose for which it was built. It is one of Ireland's most Palladian houses, and was designed by John Smith, under the influence of Burlington. There is some splendid plaster-work, and the Saloon, on the first floor, is one of the finest rooms in Dublin. At the extreme right hand side of the painting is depicted a house which no longer stands.

In addition to views, Sadler painted copies after Old Masters, imaginary, historical and mythological scenes, and all sorts of strange subjects. With him, nothing is really unexpected. Occasionally, but only very occasionally, did Sadler paint on canvas, and sometimes on quite a sizeable scale.

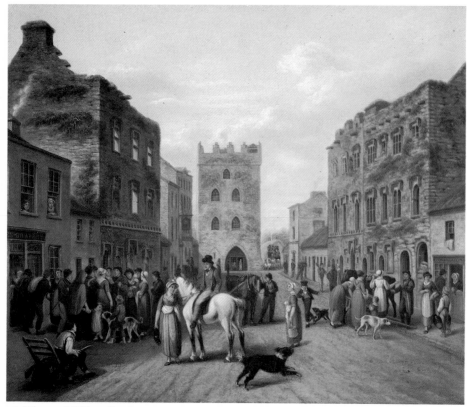

A View of Kilmallock.
JOHN GEORGE MULVANY, 1766-1838.
Oil on canvas, 68 x 80 cm. Signed: *J. G. Mulvany.*
Purchased in 1937.

Kilmallock is a market town in County Limerick, almost twenty miles due south of Limerick City.

Kilmallock had substantial fortification, tower gates, and sizeable houses. A town with a corporation, it returned two Members of Parliament until the Union of 1800. Following the Act of Union one of the MPs received a gratuity of £15,000, a not insignificant sum when adjusted to current monetary values. In a survey published in 1837, the town had a population of 1,213 inhabitants, and reference was made to its rather run-down appearance, although some fine houses were being built. Consequently, the painting represented here, although not dated, must show the town in approximately the same condition that prevailed in 1837.

The artist, who had been trained at the Schools of the Dublin Society, is chiefly remembered as a landscape painter. The account of his life does not indicate that he was anything but successful. With the foundation of the Royal Hibernian Academy in 1823 he was invited to be a founder member. In this painting he shows a rather decrepid town, but it is a very important document from the point of view of the social and economic history of an Irish town of the period. John George Mulvany is not a masterly artist, yet his modest achievement reveals a way of life long since gone. Not many of his works are known; his signature in this painting is discreetly placed in the signboard over an entrance to a shop.

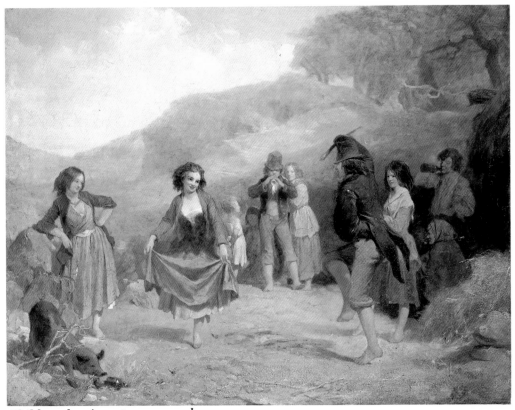

Children dancing at a crossroads.
TREVOR THOMAS FOWLER, *fl.* **1829-1844.**
Oil on canvas, 71 x 92 cm.
Purchased in 1975.

Precious little is known about the life of Fowler except for the fact that he exhibited, mainly portraits, between 1829 and 1844. A few subject pictures are recorded, including *La jeune artiste* which was won by Lady Emma Vesey of Abbeyleix in the Royal Irish Art Union lottery. These subject pictures firmly place Fowler in the group of Irish genre painters of the nineteenth century, with artists like Crowley and Haverty.,

A distinguishing characteristic of Fowler's subject paintings as known at present is the bright and cheerful colouring. This is quite evident in the painting illustrated here. The artist's overall palette is light; the crossroads are dusty earth and sandy colour; the hills and foliage are a pale olive green; the colours of the clothes of the participants and observers of the dancing are muted. The entire effect of the painting is cheerful and entertaining; this is also

true of the other known paintings of the same type by Fowler.

A full appraisal of the artist's position in the history of Irish painting must await the uncovering of more of his works. Much more biographical information is also needed.

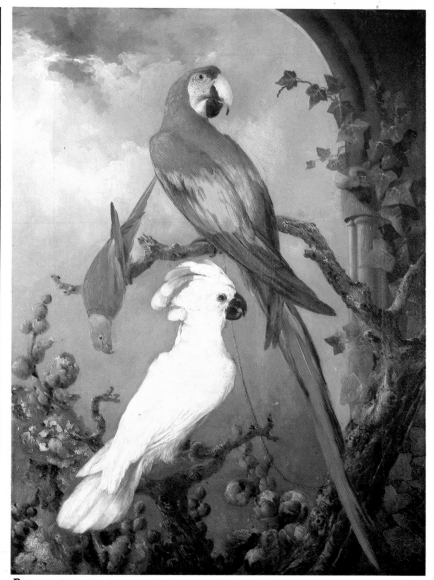

Paroquets.
EDWARD MURPHY, *c.* **1796-1841.**
Oil on canvas, 85 x 61 cm.
Purchased in 1871.

Little or nothing is known about the early life or training of Murphy. His main work as recorded is flower-painting and in still life. This genre was quite popular with Irish nineteenth century artists, but few of their works can match the painterly quality of the painting illustrated here. Murphy also did caricatures, many of which were published, and a few landscapes. He was an Associate of the Royal Hibernian Academy, and, as Strickland puts it, "died by his own hand".

Paroquets is a work of outstanding decorative quality. The exotic birds are depicted in their bold colouring, and are composed together in a tall pyramidal group; they are perched on the boughs of a tree, with the composition closed on the right hand side by the springing of an archway.

This painting recalls the very popular embossed and handcoloured watercolours of Samuel Dixon which were so fashionable in the middle of the eighteenth century. *Paroquets* formerly belonged to Sir Maziere Brady, the Irish Chancellor, who played a vital role in establishing the nucleus of the National Gallery of Ireland's collection in the early years of its foundation, by advancing monies to secure sizeable groups of paintings, some of which remain to this day among Dublin's masterpieces.

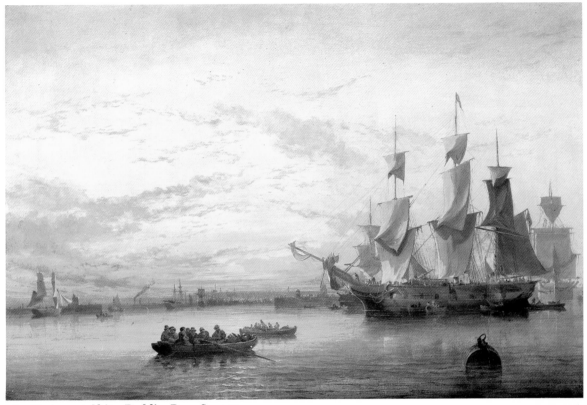

An Emigrant Ship, Dublin Bay, Sunset.
EDWIN HAYES, 1819-1904.
Oil on canvas, 58 x 86 cm. Signed: *E. Hayes, A.R.H.A. 1853.*
Presented by Miss M. Kilgour in 1951.

In his long life Hayes produced a very considerable corpus of works, all, as far as is known, strictly confined to the sea, shipping and coastlines. Hayes was born in Bristol, but at the age of thirteen came to Dublin with his father, who was an hotelier. Edwin attended the Royal Dublin Society's Schools. He sailed around Ireland in a small yacht, presumably his father's, and made that his studio. In 1852 he moved to London, and worked for a while as an apprentice to Telbin the scene painter. His creations in this occupation can scarcely be called his own. After a couple of years his paintings were exhibited at various institutions, but principally at the Royal Academy where for almost fifty years he scarcely missed a year. His horizons broadened, since, apart from views off Great Britain, he gained new locations from visits to France, Spain and Italy.

The painting reproduced here is a very poignant one. The sailing ship is at anchor towards the mouth of the river Liffey. It awaits yet more passengers for the migration of more Irishmen to the United States. It is not a sad picture; there is a sign of hope suggested by the sunset and the tranquility of the sea.

Hayes painted many small paintings, which are eagerly sought after by modest collectors, to such an extent that many small seascapes have acquired putative Hayes signatures in recent years. His work is often extremely delicate and ranges over a wide spectrum of moods. Yet it is virtually impossible to distinguish early works from late works, let alone endeavour to suggest a stylistic development.

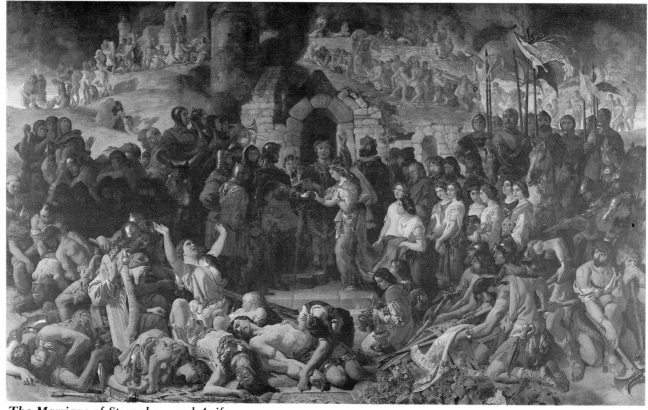

The Marriage of Strongbow and Aoife.
DANIEL MACLISE, 1806-1870.
Oil on canvas, 309 x 505 cm.
Presented by Sir Richard Wallace in 1879.

Daniel Maclise was born in Cork in 1806. After a short time as a bank apprentice Maclise began to study at the recently founded art school; at the age of twenty, in 1826, he moved to Dublin, and in the following year to London to study at the Royal Academy Schools. As 'Alfred Croquis' he contributed to *Fraser's Magazine* for about ten years. In 1844 he was one of the six artists chosen to provide paintings for the recently built Houses of Parliament.

The painting illustrated here is somewhat comparable in scale and feeling with the paintings destined for Westminster. When the Normans landed in th south east of Ireland, their progress into the country was greatly facilitated by the lack of opposition of the King of Leinster, McMurrogh Kavanagh; he endeavoured to consolidate his own position by offering in marriage his daughter Princess Aoife to the Norman leader Strongbow (Richard de Clare, Earl of Pembroke). Maclise's painting is centred on the marriage group, and moralizes in the panoramic setting of the ceremony. The disconsolate figures strewn in the foreground symbolize the destruction of the old gaelic society by the surrender to Strongbow and his impressive cavalry supporters.

This painting dates from the early 1850s, and the Gallery also owns a carefully drawn watercolour for it.

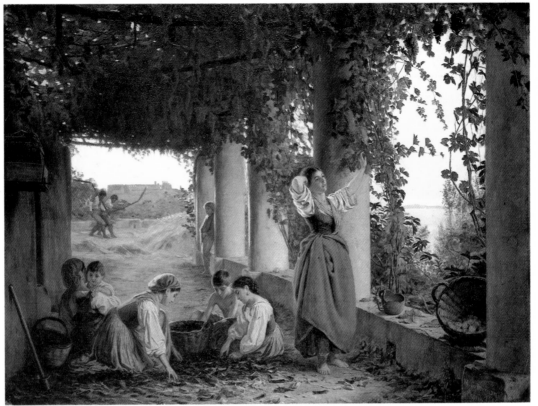

A Vine Pergola at Capri.
MICHAEL GEORGE BRENNAN, 1839-1871.
Oil on canvas, 56 x 75 cm. Signed: *M.G. Brennan Capri 1866.*
Purchased in 1873.

The artist of this painting was born in Castlebar, County Mayo. His artistic ability was observed at an early age, and, with the support of Charles O'Donel and Lady Tenison, Brennan went to Dublin where he attended the Dublin Society's Schools and that of the Royal Hibernian Academy. Later in London he did caricatures for *Fun* (a magazine like *Punch*) and attended the Royal Academy School. In London he contracted typhoid fever. Having recovered, he was advised to seek a warmer climate, and went to Italy for health rather than artistic reasons. After a while he settled in Capri; his health broke down again and he went to Algiers, where he was the guest of Lady Kingston (from Kilronan, County Roscommon, in the west of Ireland). His health, regrettably, did not recover, and he died in his forty-second year.

Several of Brennan's paintings of Capri survive. In that illustrated here one sees quite clearly the artist's ability; he is responding in subdued warm colours to the peaceful sunset of his island retreat. The principal foreground figure is nobly depicted in a gesture of fatigue at the end of a day. The Mediterranean climate is found in the sky and the pale blue sea in the background. Premature death robbed Irish artistic life of one of its finest painters of the nineteenth century.

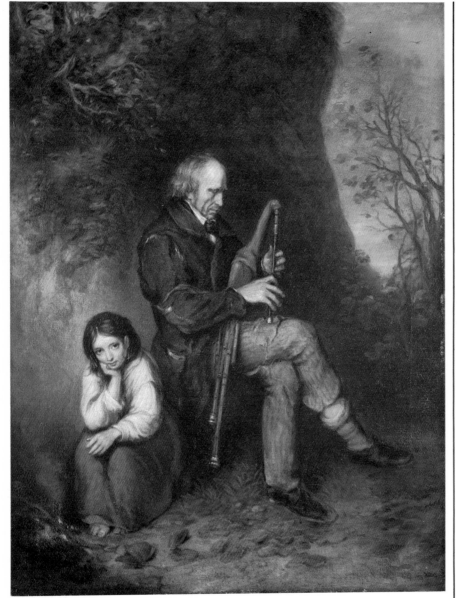

The Blind Piper.
JOSEPH P. HAVERTY, 1794-1864.
Oil on canvas, 76 x 59 cm. Presented by William Smith O'Brien in 1864.

Haverty was born in Galway and trained as an artist there, actually contributing paintings to exhibitions from that city. Subsequently, he moved to Dublin, and with the foundation of the Royal Hibernian Academy in 1823, he was made an Associate member despite his relative youth. He spent considerable periods in London and was successful in both capital cities as a portrait painter.

Haverty was rather like a "court" painter to Daniel O'Connell. Numerous portraits of "The Liberator" can justifiably claim to be the product of his brush. A good example is that in O'Connell's London club, The Reform. The Gallery owns a large group portrait showing "The Liberator" with a large gathering of supporters. O'Connell was closely involved in establishing the National Bank of Ireland, and every branch displayed prominently a portrait of him, frequently a painting, including some by Haverty. When this Bank and the Hibernian Bank merged with the Bank of Ireland the portraits of O'Connell were swept away.

As well as portraits Haverty has left posterity with some valuable narrative and genre-style paintings. Few Irish artists spent much time in this area, with the notable exception of Crowley, the Grattans, Mulready, and, later, Osborne. *The Blind Piper* is also known as *The Limerick Piper*, because tradition identifies him with that city, and Haverty lived there for some years. Another version, belonging to the Gore-Booth family was engraved, and consequently the painting is well known and admired by many people. Despite the dark colours used the painting is not melancholic; rather it is a poignant depiction of a talented performer resigned to his handicap, and a sensitive portrayal of a young child.

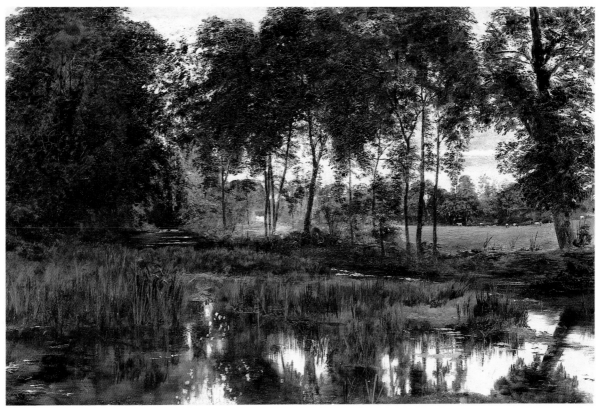

A View of the Rye Water near Leixlip.
WILLIAM DAVIS, 1812-1873.
Oil on canvas, 51 x 76 cm.
Inscribed on reverse: *Rye Water near Leixlip by William Davis.*
Purchased in 1975.

Davis was born in Dublin and early in life studied law. This he soon abandoned to attend the Royal Dublin Society's Schools. At the early age of twenty-three he felt that he was not succeeding sufficiently in Dublin, as a portraitist, and left Ireland for Liverpool. In Liverpool he became a member of the local Academy and became Professor of Painting at its Art School. Under the influence of Robert Tonge he painted mainly figure subjects and still life.

After the retirement of Tonge in 1853 Davis devoted himself almost entirely to landscape painting. Davis was a regular exhibitor at the Royal Academy exhibitions, and his work was received with much acclamation.

The painting reproduced here, is not only cheerful in colouring, but shows an extraordinary dexterity in the handling of light and shade, and in the treatment of light on water in this small tributary river, which runs into the Liffey not many miles West of Dublin. Is it possible that this painting was executed before Davis went to Liverpool? Who influenced the young artist, or was it his own invention? Very possibly Davis made return visits to see his family, and so it could postdate 1835. It would seem that the treatment of the scene was the artist's own invention. Its verve and life make it comparable to the style of the French painters Daubigny and Harpignies, instead of the fuller work of Jacque, Breton and Bonheur.

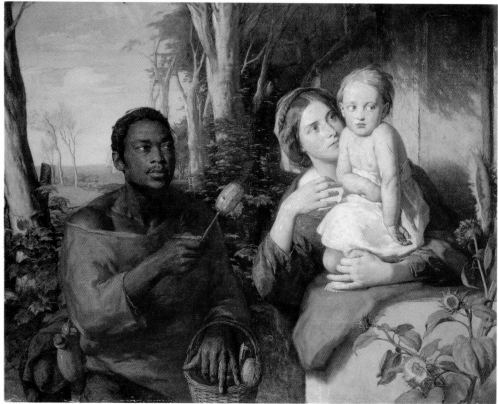

The Toy-Seller.
WILLIAM MULREADY, 1786-1863.
Oil on canvas, 112 x 142 cm.
Purchased in 1891.

Mulready was born in Ennis, County Clare. While still a very young boy his family moved to London. Despite the fact that his father was a skilled craftsman, the financial circumstances of the family were such that the artist got a modest but basic education. While a pupil with Baynes, he attracted the attention of the sculptor Banks, who brought him to his studio to draw from his sculptures.

In 1800 he was admitted to the Royal Academy School, where he was both diligent and successful. At the age of sixteen he was awarded the large silver palette by the Society of Arts. Mulready made a living by teaching, and by illustrating books. He is known to have painted landscapes, historical scenes, genre scenes. Perhaps it was the combination of working in Banks's studio and his subsequent introduction to the Life School at the Royal Academy that gave him a particular interest in the human figure.

Despite what other work he might have in hand, Mulready continued to study and paint the human form, and arguably it is in paintings such as that illustrated here that he really shows his greatest talent and dignity. The figures are masterly and placed in a skilfully composed setting. In this, and in other paintings in which the human figure is not so dominant, one finds a pale green and a pale red which almost make one feel that he is working in tempera.

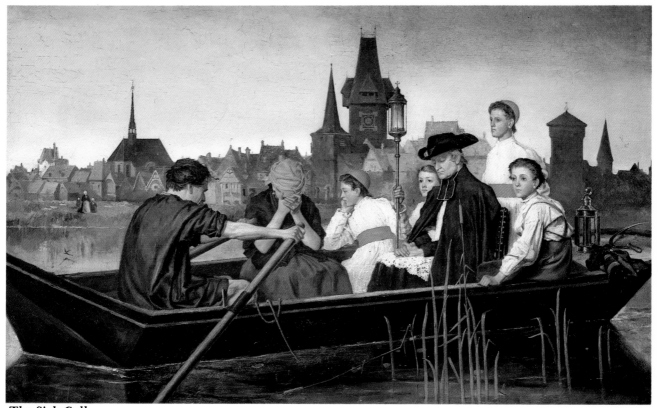

The Sick Call.
MATTHEW LAWLESS, 1837-1864.
Oil on canvas, 63 x 103 cm. Signed: *M. J. Lawless 1863.*
Purchased in 1925.

Lawless was born in Dublin. He was sent to school in England. Later he studied art under Henry O'Neill at the Langham School in London. His first exhibit at the Royal Academy was in 1858, and he continued to exhibit there each year until 1863. The works shown all portrayed narrative or homely scenes. Lawless worked as an illustrator for *Punch, Once a Week,* and *London Society.*

Lawless became ill in 1863 and died in London in the following year. Apart from the illustrations referred to, *The Sick Call* reproduced here is the only work at present known. The setting of the subject must surely be somewhere in the Low Countries, most probably in Belgium. The painting is the work of a very talented artist whose draughts-manship is absolutely unerring. The gentle colours are appropriate to the scene portrayed, while the lack of solemnity of two of the acolytes is quite natural.

Death snatched from earth a worthy exponent of pre-Raphaelite qualities; yet one can look forward to the relo-cation of some of Lawless's other recorded paintings.

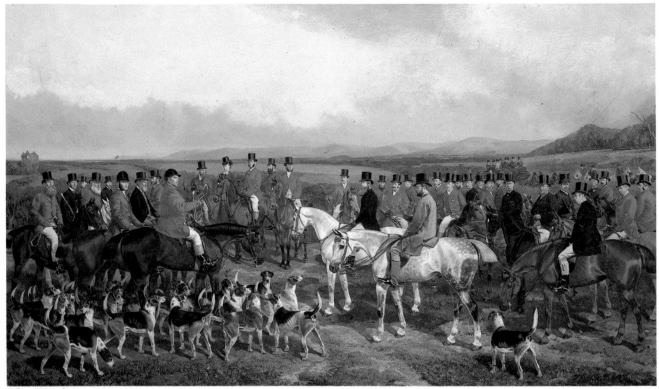

The Ward Hunt.
WILLIAM OSBORNE, 1823-1901.
Oil on canvas, 109 x 184 cm.
Presented by Mr. W. Jameson in 1927.

For a nation addicted to the Turf, Ireland has produced but few painters of horses, hunting and racing. George Nairn, Michaelangelo Hayes and William Osborne are the principal artists. Of these Hayes is probably the only outstanding artist, working in watercolours and preparing drawings for engravings such as those of the Bianconi horse-drawn inter-city service coaches.

Osborne studied at the Royal Hibernian School and began exhibiting in the early 1850's. There is no doubt that his paintings of dogs are his most accomplished work known today. Rather than the single portraits, his groups of dogs are quite delightful, often showing a sense of humour or caprice. Experts in the knowledge of dogs are struck by the perception of their habits and anatomy which Osborne shows. No dog picture by Osborne is in the Gallery's collection, but there are several notable ones in private collections.

Osborne painted horses singly and in small groups. The Ward Hunt illustrated here is clearly a command performance. The hunt is a famous stag hunt based in North County Dublin, and is known today as the Ward Union Hunt. Osborne's painting shows the hunt in 1873; the members are identifiable through a key which was engraved. From photographs which survive of some of the participants one concludes that the artist was very accurate in the portraits painted; at the same time it is quite clear that he was capable of controlling a large composition, which in this work is a major document for the history of hunting in Ireland.

Miss Purser came from a prosperous Irish middle class family. She studied painting both in Dublin and Paris. She built up a very extensive practice as a portrait painter both in England and Ireland. Such works were conventional, with no special personal quality to distinguish them from a host of other good portrait painters of the period. She did, however, execute some delightfully informal paintings, such as that reproduced here; most of these are owned by members of her own family, and by the families of her friends. In this charming little work the painter is taking delight in the quality of paint, with the whites, blues and reds superimposed with great freedom.

Miss Purser was also an organizing force. In 1903 she undertook the foundation and management of *An Túr Gloine* (The Tower of Glass) stained glass studios. The works of this cooperative are still frequently called "Miss Purser windows". Miss Purser herself did very few designs which were executed under the direction of A. E. Child, the Englishman brought over to teach young Irish artists the technique of this difficult medium.

Miss Purser lived at Mespil House, just to the south of the Grand Canal in Dublin. The house from outside was not very impressive, but inside contained some of the finest Irish plasterwork ceilings of the eighteenth century, which were rescued before the house was demolished. In her drawing room, on a specified afternoon, the literary, dramatic, artistic, and indeed scientific personalities of Dublin met. There, many of the cultural achievements of Ireland, in the first decades of this country, were conceived.

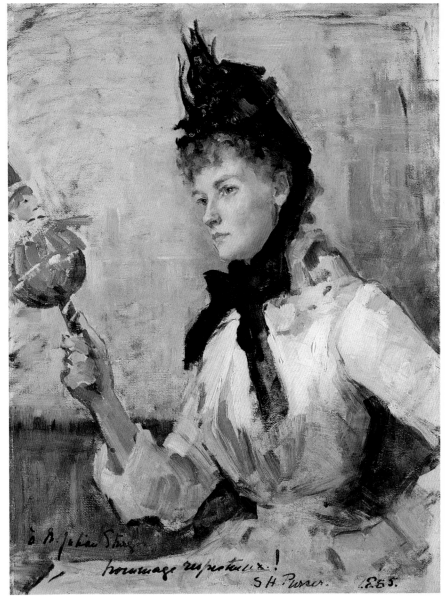

A Lady Holding a Doll's Rattle.
SARAH PURSER, 1848-1943.
Oil on canvas, 41 x 31 cm. Signed: *S. H. Purser 1885.*
Purchased in 1975.

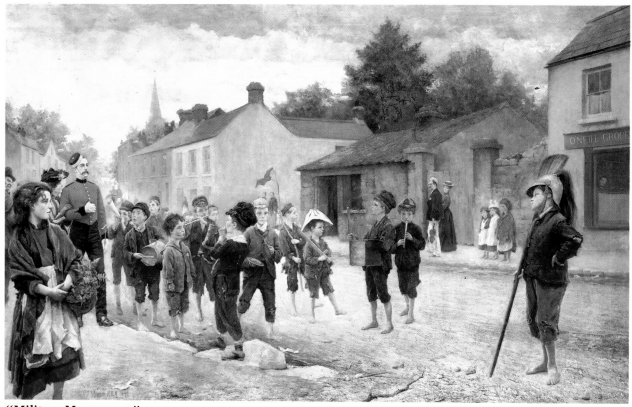

"Military Manoeuvres".
RICHARD T. MOYNAN, 1856-1906.
Oil on canvas, 148 x 240 cm. Signed: *R. T. Moynan R.H.A. 1891.*
Purchased in 1982.

Moynan was born in Dublin. Having spent several years studying medicine at the Royal College of Surgeons of Ireland, he abandoned that discipline for the one which he really wanted. He studied at the Royal Dublin Society's School, the Royal Hibernian Academy's School, the Academy at Antwerp, and in Paris under instruction from several leading artists. He settled in Dublin in 1886.

The view has not been identified, and it may be imaginary, although it is almost certainly intended to represent a scene in Ireland. Some clue to its location may be provided by the church spire in the background. Beside O'Neill's grocery shop there is a forge with a furnace burning; the forge sign is attached to the top of the gate pillar. The man on the far pavement is dressed for tennis and he carries a square tennis racket. The children pretend to be soldiers, as a soldier and his girl friend pass by. The soldier in this painting is a trooper (a private of a cavalry regi-ment) wearing the walking-out dress of the 4th (Royal Irish) Dragoon Guards, a regiment which was stationed in Ireland in the late 1880s and early 1890s. The boy on the extreme right-hand side wears a brass helmet with a black horse-hair plume. This is the appropriate head apparel for the band of the soldier's regiment.

As well as painting charming genre scenes, Moynan also executed land-scapes and portraits.

Walter Osborne never fails to charm. Some of his most enchanting pictures are the views of the older parts of the city of Dublin, vibrant with the life that kept them still alive. Children invariably play the important part in his works, either out of doors, or indoors, as in this charming group of children seated around a tea table.

The apparent ease with which the painting reproduced here is painted was not achieved without effort. Osborne studied at the Royal Hibernian Academy's School, and later at Antwerp; his earliest works are tight by comparison with *The Lustre Jug*, yet they already have a quality of light that is a hall mark of his career. For a number of years he lived in England; he also visited Spain and Holland. Shortly after leaving the Schools, his brushwork became freer, and paint was applied to canvas and panel with an unerring "dash". This, combined with his sensitivity towards light effects, secured for the artist an admiring clientèle. That freedom of brushwork and appraisal of light is clearly demonstrated in *The Lustre Jug*. Those same qualities are evident in his masterpiece, the unfinished *Tea in the garden*, which belongs to the Hugh Lane Municipal Gallery of Modern Art, Dublin. The garden immortalized in that painting is the simple garden of his Dublin home.

Osborne's premature death robbed Ireland of one of its greatest artistic talents at the threshold of the twentieth century. Yet by his assiduous work he left posterity a fine corpus of works, including many pencil sketches from which subsequent pictures were derived.

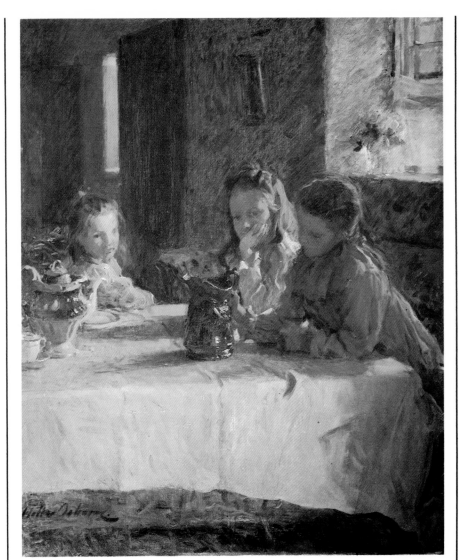

The Lustre Jug.
WALTER OSBORNE, 1859-1903.
Oil on canvas, 76 x 61 cm. Signed: *Walter Osborne*.
Purchased from the artist's Executors, in 1903.

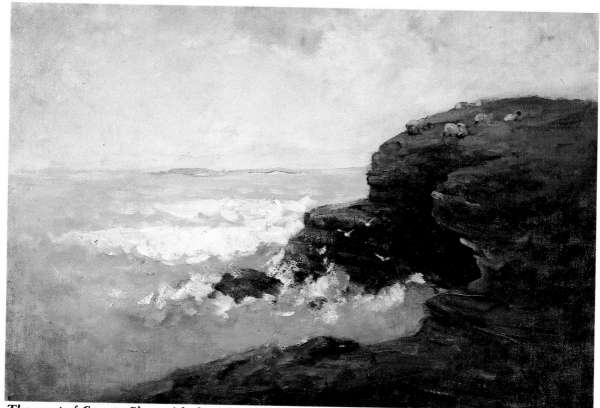

The coast of County Clare with the Atlantic.
NATHANIEL HONE THE YOUNGER, 1831-1917.
Oil on canvas, 61 x 92 cm. Signed: *NH.*
Hone Bequest, 1919.

Hone, having studied engineering at Trinity College, Dublin, worked for the Midland Great Western Railway. At the age of thirty-two he took up painting, by studying in Paris under Yvan and Couture. His real training came when he went to Barbizon in 1855, and later to Fontainebleau. Apart from some travel, he spent twenty years between Barbizon and Fontainebleau.

In 1875 he returned to Ireland and settled at St. Doulough's, near Malahide in County Dublin. He painted continuously, but, because he had a reasonable private income, he made little effort to sell his paintings.

Many of Hone's finest works were given to friends and family. His wife survived him by two years, and she bequeathed the "studio contents" to the National Gallery of Ireland. The oil paintings alone number more than two hundred works. Hone's approach to painting was so energetic that even when thirty or forty of his paintings are hung in close proximity the viewer is never even mildly bored.

Hone was a true son of the nineteenth-century Fontainebleau School, and when painting in Ireland he grasps the essential elements of the view to be depicted. In the painting reproduced here one gets a vivid sense of the Atlantic waves crashing against the timeless rocks of the Western coast. Most of his paintings are landscapes; many are unpeopled, but a surprising number do include cattle, goats, ships, ruins, while fewer contain shepherds or goatherds. Hone was prolific as a watercolourist, and many of his rapid sketches were later the basis for works in oils.

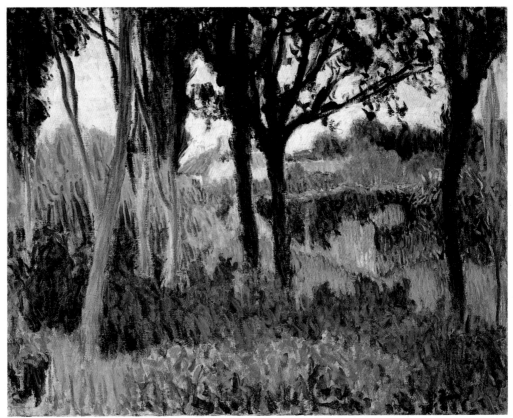

La ferme de Lezaver, Finistère.
RODERIC O'CONOR, 1860-1940.
Oil on canvas, 72 x 93 cm. Signed: *O'Conor 1894*.
Purchased in 1961.

O'Conor was a member of a cadet branch of the family of the last Gaelic High King of Ireland, whose mainline descendant is known to this day in the English form of "The O'Conor Don". Little is known about his early tutelage in the art of painting; he is recorded as having visited Antwerp in 1881, and in 1883 he was working under the direction of Carolus Duran in Paris. Having at least a small private income, he was able to settle in France, paint and not worry too much about selling his pictures. He was one of the significant members of the Pont-Aven group which included Gauguin. Pont-Aven is a little port in the province of Finistère which reaches out into the Atlantic ocean. In and around this centre a number of artists painted; places such as Concarneau and Quimperle are the location of many scenes painted by many artists.

As can be seen in this painting, Impressionism is over; the canvas can really be considered as an example of the style known as *Fauve* (savage); the description of the style owes much to the audacity of the painters; here strong brushstrokes of deep green, purple, and lavender, daringly flung on the canvas, create in the viewer a feeling of appearing to be standing in the foreground of the painting.

The Gallery also owns *A landscape with Rocks* (No. 4057), which could easily be mistaken for a Matthew Smith. It is interesting to note that the Cornish painters at the beginning of the twentieth century were very much in harmony with those working in what remained the most Celtic area of France.

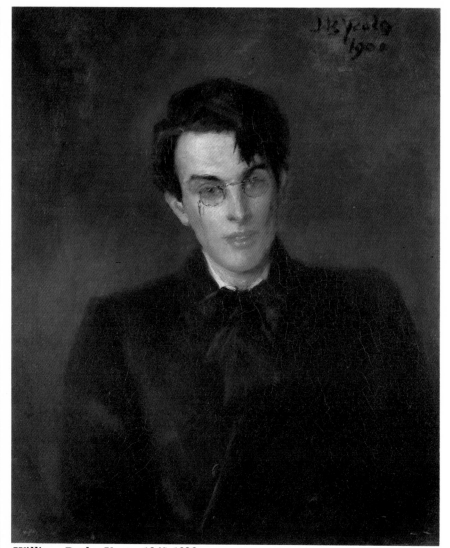

William Butler Yeats, 1865-1939.
JOHN BUTLER YEATS, 1839-1922.
Oil on canvas, 77 x 64 cm. Signed: *J. B. Yeats 1900*.
Presented by Mr. C. Sullivan in memory of Mr. J. Quinn, in 1926.

The painter of the portrait illustrated here said that he would be remembered more as the father of a painter than as the father of a poet. First of all there is undue modesty in this statement, since John Butler Yeats is remembered as a fine portrait painter. When he made the statement William Butler Yeats had achieved success, and was at that time better known abroad than his brother, Jack B. Yeats (see page 50). The father of these two celebrities, and the founder of a dynasty of artists that may be compared in the future with the Hone family, was slow to develop.

The son of a Church of Ireland Rector, John Butler Yeats had a traditional education, reading classics and philosophy at Trinity College, Dublin, and being called to the Irish Bar. It was only some years later that he went to London, with his wife, Susan, and studied art seriously, first at Heatherley's, and later at the Royal Academy School. Undoubtedly he was facilitated in this by having inherited the family estate of 626 acres in County Kildare when his father died in 1862.

John Butler Yeats has left thousands of pencil sketches of people of all walks of life; he had a remarkable skill for these. Many are in public collections; others belong to private indiciduals, who would not claim to have collections; and of course his family own many more. The artist's portraits in oil combine a good solid foundation in traditional principles, infused with an ever-increasing tendency towards Impressionism. They always seek to reveal the personality behind the facial mask, and in this they succeed.

The Harrisons were an Ulster family. When Sarah's father died her mother took the family to live in London. After her schooling Sarah went to the Slade. Late in the 1880's she settled in Dublin and was successful as a portrait painter. Her style was firm and orthodox, and her most attractive works are undoubtedly those small portraits, such as the example reproduced here.

After an informal schooling, Hugh Lane was apprenticed to Colnagni's, the London art dealers. A few years later, with scarcely no money, he embarked as a dealer on his own. His success was meteoric, and it was really his choice which formed the basis of several well known collections. Lane never lost touch with his native Ireland. In 1902 he orgaiized an exhibition of Old Masters at the Royal Hibernian Academy; in 1904 he arranged an exhibition of Irish art in London; in the same year he was appointed a Governor and Guardian of the National Gallery of Ireland. In 1914 he was made Director of the Gallery. A little over a year later he perished when the Lusitania was torpedoed in sight of the coast of Cork.

Lane in many people's minds is linked with the thirty-nine important modern paintings, the ownership of which has long been the subject of debate between Dublin and the National Gallery, London. For over twenty years now, through two separate agreements, London loans to the Hugh Lane Municipal Gallery of Modern Art, Dublin, a portion of that collection. The notoriety of these modern paintings has led many people to forget the sixtyseven paintings given and bequeathed by Lane to the National Gallery of Ireland. Such is the quality of this munificence that any city would welcome it as the basis for the foundation of a public collection.

Sir Hugh Lane, 1875-1915.
SARAH CECILIA HARRISON, 1863-1941.
Oil on panel, 41 x 31 cm.
Purchased in 1954.

A Convent Garden, Brittany.
WILLIAM J. LEECH, 1881-1968.
Oil on canvas, 132 x 106 cm. Signed: *Leech*.
Presented by Mrs. M. Botrell, in 1952.

The son of a Dublin professional family, Leech, like many other embryonic artists, was not dissuaded from his pursuit of art. He studied at the Royal Hibernian School, where Walter Osborne was teaching; previously he had acquired a good foundation at the Metropolitan School of Art. In 1901 he went to Paris where he pursued his study under Bougereau and Laurens. More significantly, he moved to Brittany in 1903. Places such as Concarneau feature in his paintings, but yet he does not seem to have been in the kernel group of the Pont Aven School.

Arguably the painting reproduced here is as advanced as any of the works of the first decade of the century painted in Brittany; perhaps it lacks that slightly "savage" facet which gave to the Fauves their name. Leech is gentler. Rich vegetation invariably absorbed him, as well shown in this convent garden. The painting is striking because of its extremely vivid lemon yellow and the light greens; the striking figure of what one presumes is a nun is more like a dignified model from the world of *haute couture*. On a smaller scale his studies of boats and harbours, of gardens and parks, are usually more subdued in colouring, and consequently remove him from the thrust of the painters focused around Gauguin.

Leech kept in regular contact with his native Dublin, exhibiting at the Royal Hibernian Academy and group shows. He was made a full member of the Academy in 1910. He settled in England in 1916, but continued to participate in Irish exhibitions. The years in Brittany inspired works like that illustrated; afterwards, more subdued colouring is conspicuous. The power of composition was something which he never lost.

At the time of the centenary of Orpen's birth there was much talk around Dublin of a renewal of interest in this half-forgotten artist. While it may be true that in Ireland his works had become rather unappreciated, the activities of the London salesrooms and commercial galleries never lost sight of the talented Irish painter. Copious sketches, society portraits, portraits of friends and family, the works of one of the officia! War Artists, and a number of very attractive subject pictures which are too refined to be covered by the word *genre*, always commanded respect and relatively high prices in London.

The Vere Foster Family was painted at Glyde Court, County Louth, during the summer of 1907. Orpen got the commission through Hugh Lane. The artist believed it to be his finest group portrait, but several contemporary critics ridiculed it. Today it is still a painting which delights many and annoys others.

The Foster family in County Louth gave much public service to the nation and the county. The famous Speaker Foster was a cousin of the Fosters of Glyde Court; the family included several members of parliament and clergymen. The Vere Fosters are particularly noteworthy because of the help they gave to those who were forced to emigrate after the famine years, and because of services to education. The portrait represents Sir Augustus Vere Foster, Bt., his wife, and two daughters, the younger of whom lived at Glyde Court until very recently. The house was remodelled in the nineteenth century and it is not particularly attractive, but the property is delightful, with many fine trees and shrubberies, and its situation on the banks of the river Glyde.

The Vere Foster Family.
WILLIAM ORPEN, 1878-1931.
Oil on canvas, 198 x 198 cm.
Purchased in 1951.

46

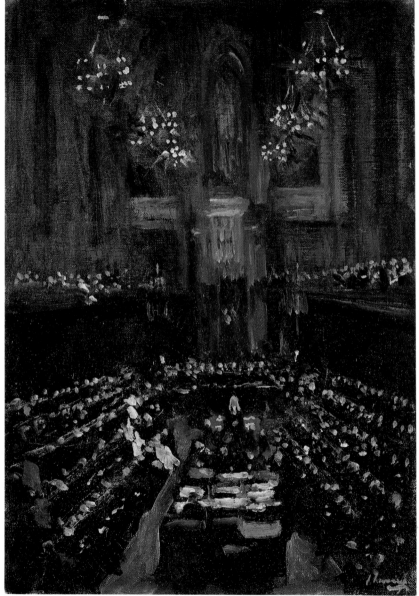

The Ratification of the Irish Treaty in the House of Lords, 1921.
JOHN LAVERY, 1856-1941.
Oil on board, 36 x 26 cm. Signed: *J. Lavery.* Purchased in 1963.

Sir John Lavery is claimed by the Ulster School, the Glasgow School, the British School and the Irish School. The plain fact is that he belongs to all of these and shows how art and artists can break down barriers between regions and countries. Born in Belfast, Lavery was orphaned while virtually an infant. An uncle in Co. Down took care of him and his brother. As a teenager he took a job with a photographer in Glasgow, and attended night classes at the Haldane Academy. Having acquired a certain financial independence he went to art school in London, and in 1881 went to Paris. He studied under various artists including Bougereau. He lived at the artists's colony at Grès-sur-Loing for about two years from 1884. Later travel brought him to Morocco, Italy, Spain, Germany and Holland.

Lavery became a highly respected portrait painter, and is to be grouped with artists like Sargent and Orpen, even if he did not acquire the notoriety of his fellow Irishman. His professionalism is unquestionable. During the 1914-1918 War he was appointed an official war artist. The sketch reproduced here records a very momentous event for Ireland, the foundation of the Irish Free State, which led to the Civil War, which tore families asunder and which was a poor handicap for the new government of Ireland until the opposition to the Treaty decided to enter parliament as an opposing party.

Lavery designed the bank notes of the new Irish state, the subject for "Ireland" being Laverty's own wife. The picture is inscribed on reverse: *Painted in House of Lords on the afternoon of 16 December 1921.*

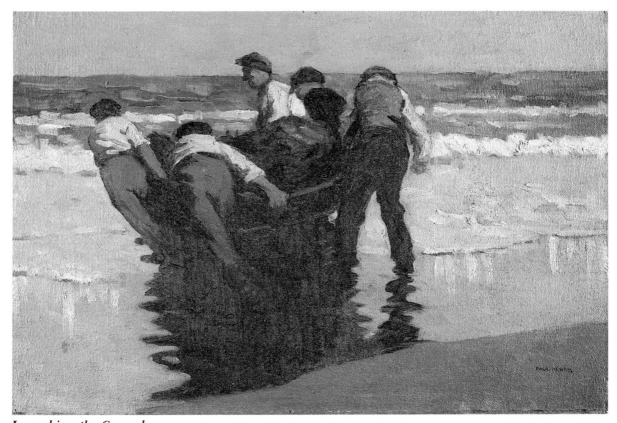

Launching the Currach.
PAUL HENRY, 1876-1958.
Oil on canvas, 41 x 60 cm. Signed: *Paul Henry.*
Purchased in 1968.

Born in Belfast, the son of a clergyman, Paul Henry was educated at the Belfast Academical Institution. After school he was apprenticed to a damask designer, and also attended the Belfast School of Art. In 1898 he went to Paris to study at the Académie Julien; about two years later he settled in London, where he earned a good living by doing illustrations for various periodicals. It would appear that he settled on Achill Island, County Mayo, in 1912, and there began his life long romance with the landscape of the West of Ireland and the Atlantic seaboard.

Paul Henry has left a legacy of a very penetrating observation of Irish landscape of this area; his works are realistic; yet he has exercised sufficient selection to raise his canvases above any hint of the banal. He sometimes introduced figures into his paintings. As in the example illustrated here the figures are always robust, and their action is palpable; the fishermen's love of the sea is virtually implicit in this view of a few men drawing a currach across the shallow flat to meet the Atlantic breakers.

Paul Henry lost his sight in 1945, the greatest blow that an artist could suffer, even though he was in his late sixties. Living in County Wicklow, he proved to be resilient and wrote his autobiography.

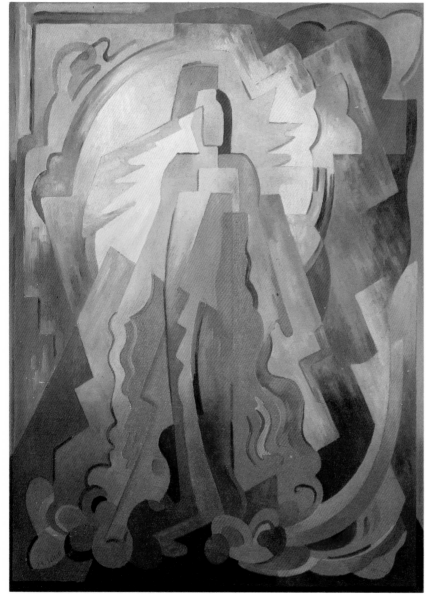

"I Have Trodden the Winepress Alone".
MAINIE JELLETT, 1897-1944.
Oil on canvas, 76 x 56 cm. Signed; *M. Jellett.*
Bequeathed by Miss R.S.R. Kirkpatrick, 1979.

Born into a notable Dublin professional family, Mainie Jellett was to become one of the seminal figures in the history of Irish painting in the first half of this century. Initially she studied under Elizabeth Yeats, Cecilia Harrison, and Mary Manning; she then attended the Metropolitan School of Art before going to London at the age of twenty, where she attended the Westminster School of Art. In 1921 she went to Paris, accompanied by Evie Hone, to study under André Lhôte; after a short while they both turned to Albert Gleizes. Cubism was not a novelty in Paris, but Gleizes was continuing his quest in this area, an approach to painting that was more than fifteen years old.

Until 1931, each year Mainie Jellett (and Evie Hone) returned to Paris for a study sojourn under Gleizes. Basically they were analysing great masterpieces, by extracting from them the underlying geometrical forms, seeing how these formed the structure of superlative paintings. A painting like *Homage to Fra Angelico* by its very title explains the approach. Simultaneously she executed some non-representational compositions which could not be linked to existing paintings.

This long research and reflection bore fruit in her later work. Cubist analysis was transformed into an inner discipline which became the structural fibre of quite realistic paintings. The painting illustrated here, which was painted in 1943, is a return to the source, insofar as a figure is not that easily perceived. The title comes from the thirtysixth chapter of *Isaias*, and the figure is one who is suffering and disowned by his own people, another prefiguration, quite clearly, of Christ.

Snow at Marlay.
EVIE HONE, 1894-1955.
Oil on board, 37 x 49 cm. Signed; *E. Hone.*
Presented by the Friends of the National Collections of Ireland in 1957.

Evie Hone was born into a virtual dynasty of painters. Those recorded are Nathaniel Hone the Elder, and his two sons, Horace and John Camillus. Later there was Nathaniel Hone the Younger, and the line flourishes to this day. Evie Hone, with Mainie Jellett, studied for a couple of months of each year, from 1922 to 1932, under Albert Gleizes, the French Cubist painter. One of the main functions was to analyse the composition of Italian painting, particularly of the fifteenth century. This knowledge became like an inner structural discipline of Evie Hone's later work.

Evie Hone became interested in stained glass, mainly through visits to French Cathedrals. In 1933 she made her first panels, and shortly afterwards became a member of the cooperative *An Túr Gloine* (The Tower of Glass) stained glass studios. When the co-operative was dissolved in the 1940s Evie Hone established a workshop at Marlay, Rathfarnham, just below the Dublin hills. Appreciated at home, in England, and further afield, as an artist in stained glass she became an international figure on account of the enormous East window which she made for Eton College Chapel (1949-1952).

In her leisure hours, she clearly enjoyed painting works like the small oil reproduced here. The colouring may seem strange, but in fact it is a true depiction of tones visible at Marlay in winter.

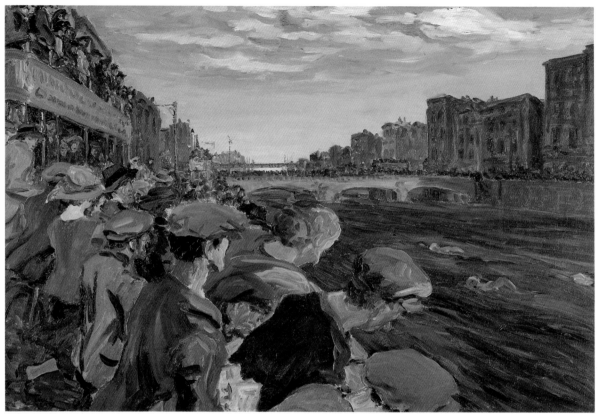

The Liffey Swim.
JACK B. YEATS, 1871-1957.
Oil on canvas, 61 x 91 cm. Signed: *Jack B. Yeats.* Painted in 1923.
Presented by The Haverty Trust in 1931.

The early works of Yeats are incisive and realistic sketches of scenes in the West of Ireland. He loved the sea, the ships, the tiny ports, and the seagulls. Much of his early income came from commissioned illustrations.

Given the development of Yeats as a painter, it is difficult to represent him by one work alone. *The Liffey Swim* of 1923 shows how interested this artist was in describing places and the people which made them live. In this painting the location can be clearly identified, Dublin's main liquid artery, the dear and rather dirty Liffey, approaching O'Connell Street Bridge. The freedom with which the figures are delineated, the warm tones freely juxtaposed to show the red-brick quayside buildings are a harbinger of future developments. Above all *The Liffey Swim* creates a great sense of occasion. Yeats loved occasions, the arrival of a trawler in port, a circus act, a racecourse finishing post. Yeats's later canvases are not as easily read; they remain occasions or statements; he did not want particularly to "explain" them. The impasto became thicker and thicker; colours became more and more daring; the mystery of the subject increased. The integrity of the artist remained. Yeats can not be classified under any School or "ism". He was himself; he was Irish.

INDEX